MODERN AMERICAN REALISM

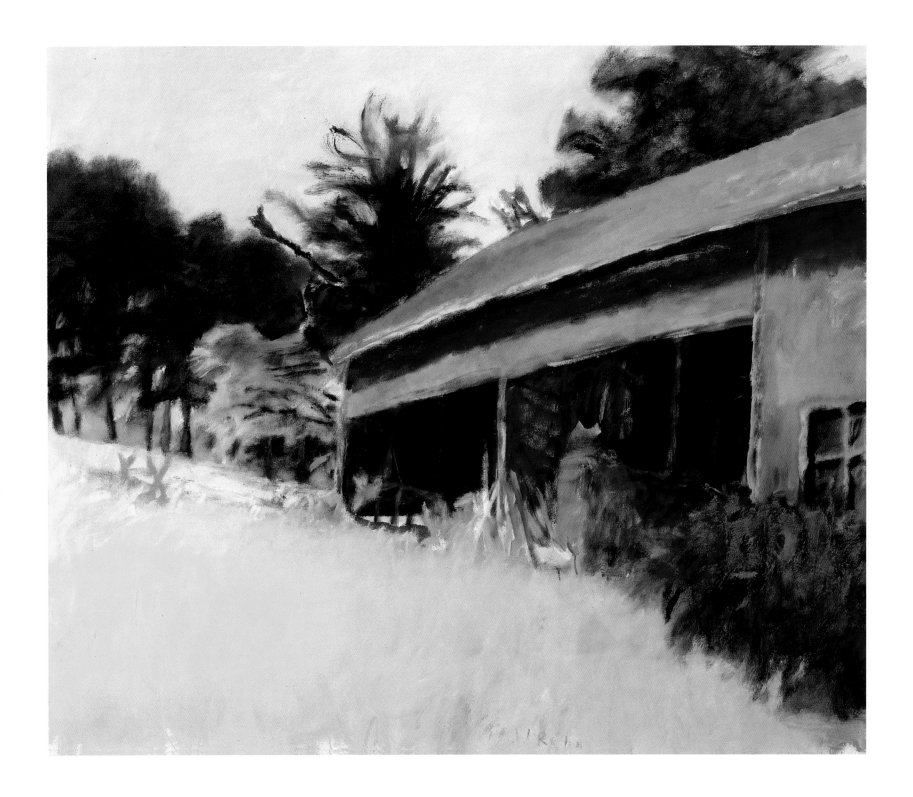

Virginia M. Mecklenburg

With an essay by William Kloss

MODERN AMERICAN REALISM
The Sara Roby Foundation Collection

National Museum of American Art
Smithsonian Institution

Distributed by the University of Washington Press

Reprinted in 1998 for the touring exhibition
Modern American Realism:
The Sara Roby Foundation Collection
Organized by the National Museum of American Art,
Smithsonian Institution, Washington, D.C.

LIBRARY OF CONGRESS CATALOG NUMBER 97-33804

Mecklenburg, Virginia M. (Virginia McCord), 1946–

Modern American realism: the Sara Roby Foundation
Collection / Virginia M. Mecklenburg.
 p. cm.
 Catalog of an exhibition at the National Museum of
American Art.
 Includes bibliographical references (p.).
 ISBN 0-87474-691-4
 1. Art, American—Exhibitions. 2. Art, Modern—20th
century—United States—Exhibitions. 3. Sara Roby
Foundation—Art collections—Exhibitions. 4. Art—
Washington (D.C.)—Exhibitions. 5. National Museum of
American Art (U.S.)—Exhibitions.
 I. National Museum of American Art (U.S.) II. Title.
N6512.M38 1998 97-33804
709′. 73′074753–dc21 CIP

Cover: Will Barnet, *Sleeping Child* (see page 22)
Frontispiece: Wolf Kahn, *High Summer* (see page 76)
Back cover: Robert Vickrey, *Fear* (see page 140)

Photo of Sara Roby by Christina Wohler, New York

Originally edited by Terence Winch. Additional materials for
the reprinted edition edited by Janet Wilson; cover designed
by Robert Killian. Typeset in Electra® and printed in Italy on
GardaMatt Art by Mariogros Industrie Graphiche.

Contents

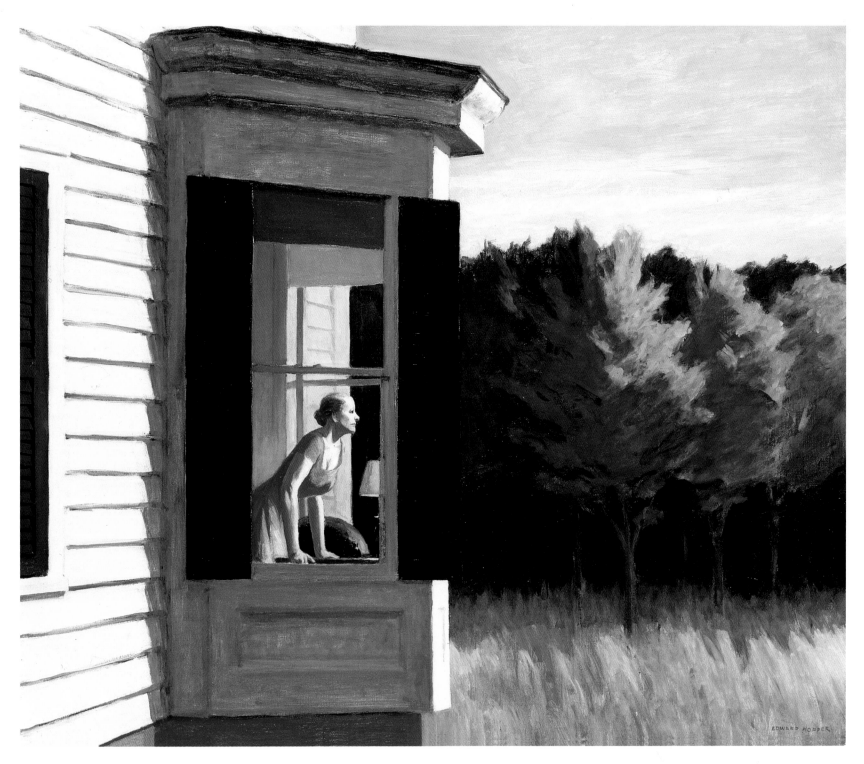

Edward Hopper, *Cape Cod Morning*

The Sara Roby Foundation Collection at 45

Ten years ago the National Museum of American Art opened the exhibition *Modern American Realism: The Sara Roby Foundation Collection* to unveil the foundation's 1985 gift of 175 paintings, sculpture, and drawings by 110 artists. Sadly, Sara Roby died before the show opened, so the celebration of a permanent home for the collection became a memorial honoring her vision.

The exhibition attracted thousands of people, many of them artists, who had held fast to the belief that the figurative tradition championed by Mrs. Roby, Lloyd Goodrich, Isabel Bishop, and the other members of the foundation's board had continuing relevance. As is apparent from the bibliography, the intervening years have validated their choices. Including books and articles published since 1985, it attests to the remarkable popular and scholarly interest in the tradition of realism in American art.

Since the gift of the collection to the museum, the foundation has continued its commitment to education in American art by contributing scholarship funds to the Art Students League and the School of the Pennsylvania Academy of the Fine Arts, two institutions with which Mrs. Roby had close ties. Recently the foundation has also provided funds for graduate fellowships in art history. In September 1996 Sara Doris became the first Sara Roby Fellow in twentieth-century American realism and in April 1997 Randall R. Griffey was awarded the second fellowship. To help reach a younger audience, the foundation also made possible the publication of *Li'l Sis and Uncle Willie*, an award-winning book based on the life and paintings of William H. Johnson by Gwen Everett.

Now that a decade has elapsed, it is time to send this remarkable collection on tour and to make available the catalogue, which has long been out of print. This "second printing" is slightly altered from the first to include the foundation's gift of additional paintings by Arthur Dove and Roy Moyer, death dates for several artists, and a bibliography.

It is an honor and a pleasure to thank Joseph Roby III, Asbjorn R. Lunde, Konrad Kuchel, Paul Cadmus, Wolf Kahn, and so many others whose friendship and support of the National Museum of American Art began with the Sara Roby Foundation Collection. It is also a special pleasure to thank Arthur R. Blumenthal, director of the Cornell Fine Arts Museum at Rollins College, for his enthusiasm and encouragement.

VIRGINIA M. MECKLENBURG
Senior Curator

Realist Choices:
A History of the Sara Roby Foundation Collection

VIRGINIA M. MECKLENBURG

The Sara Roby Foundation Collection of recent American art began over dinner one night in the early 1950s. Reginald Marsh held a large party and seated Sara Roby, whose newly formed foundation was foundering for lack of purpose, next to Lloyd Goodrich, then Associate Director of the Whitney Museum of American Art. Goodrich recalls:

Sara Roby, 1977

"Mrs. Roby told me about her foundation [and] we discussed our mutual beliefs in the fundamental importance of form and design. She said that to support these beliefs she was collecting European paintings of the past. I suggested that the most direct way . . . was to buy the work of living American artists whose art embodied form and design. She agreed, and shortly thereafter we began to form the collection."[1]

A glance through the collection today reveals the diversity that has characterized the foundation's purchases over the thirty-four years since its establishment. Stylistically heterogeneous, the collection includes mostly realist paintings, sculpture, and drawings that reflect an overriding concern with form. Although not the result of a single sensibility—over the years board members have played active roles in recommending works for purchase—the collection's driving force was Sara Roby, her taste its common denominator.

Sara Mary Barnes Roby was born in Pittsburgh in 1907. The daughter of a wealthy industrialist, she attended private schools in Philadelphia, was a student at Vassar College for a year, then studied at the Pennsylvania Academy of the Fine Arts. She became a painter whose quiet still lifes and landscapes are grounded in beauty and embody the traditional artistic values she learned during her long association, from the 1940s into the 1960s, at the Art Students League, where she studied with Reginald Marsh and Kenneth Hayes Miller. Marsh, especially, became a friend and encouraged the benefactress in her decision to organize a foundation.

A shy but independent woman, Roby had a strong sense of social responsibility and wished to help young artists and educate the public. In 1952 she established the John Barnes Foundation, named for her father, "to foster, aid and encourage in the United States of America the public appreciation, creation, enjoyment and understanding of the visual arts."[2] With a block of oil stock and a Paris street scene by Maurice Utrillo as capital assets, the John Barnes Foundation opened for business. Initially, the foundation's goals were left vague to allow for future flexibility, but this also meant that during its first two years, the program lacked a cohesive focus. The foundation did experiment, however, with a variety of activities. To support young artists, Roby held a series of exhibitions in 1953 at her Carnegie Hall studio.[3] The foundation also bought Giovanni Pannini's 1734 *Interior of the Pantheon* and Georges Seurat's *Bridge on the Seine* and lent them to university museums for public display.

It was Roby's encounter with Goodrich that provided a direction, and soon the acquisition of works by living Americans became the foundation's primary activity. Goodrich's discerning eye, his encouragement of promising young talent, and his commitment to contemporary American art coincided with Roby's growing predilection for recent American painting. By the end of 1955, the John Barnes Foundation had purchased works by Reginald Marsh, Isabel Bishop,

Paul Cadmus, Edward Hopper, Lyonel Feininger, Andrew Wyeth, and others.

Sara Roby established the foundation just as Abstract Expressionism was emerging as the major force in New York art circles, a development that prompted leading figurative artists, several of them friends, to protest what they perceived as the neglect of—even prejudice against—representational art in the New York art world.[4]

Yet Roby refused to allow the debate to color her choices. Despite her own preference for realism, with Goodrich as her mentor Roby looked as closely at abstract art as she did at paintings more in line with her own way of working. Unhindered by stylistic biases, she bought abstractions by Mark Tobey and Louise Nevelson, Expressionist pieces by Hyman Bloom and George Grosz, and realist masterpieces by Edward Hopper and Honoré Sharrer. Works by new talent joined pieces by the nation's foremost painters, with quality being the decisive factor. She also attempted to purchase a sculpture by David Smith in 1958, the same year she bought Philip Evergood's *Dowager in a Wheelchair* and Paul Cadmus's *Night in Bologna*, although Smith refused to proceed with the sale after a disagreement over payment. Her enthusiasm for a painting by Hans Hofmann was chastened by its price tag, and the painting remained with the dealer.

The unifying thematic element behind the foundation's early purchases was the recognition that human subjects can be powerfully expressed in a variety of styles, and in this respect the collection makes a particularly important contribution to our awareness of the issues at stake in mid-century American art. Socially concerned artists who came to prominence during the 1930s—among them Reginald Marsh, Isabel Bishop, and Kenneth Hayes Miller—were well represented, as were a number of their Expressionist colleagues. Bloom's emotionally wrenching *Beggar*, Grosz's sardonic *Hunger Fantasy*, and Jack Levine's satiric *Inauguration* reflect their artistic origins in German painting from the early twentieth century. In contrast, Robert Vickrey's *Fear* and Paul Cadmus's *Night in Bologna* probe the concern with angst and psychological dislocation typical of existential thought in the 1950s.

In 1956, for legal reasons primarily, but also to avoid confusion with the Barnes Foundation of Merion, Pennsylvania, it seemed advisable to amend the charter. In March of that year the John Barnes Foundation was re-established as the Sara Roby Foundation. Although the foundation's stated aims did not change along with its name, new forces did come into play. The original trustees were replaced by new board members, most of whom were associated with the Whitney Museum of American Art, and a formal arrangement was instituted by which the Whitney agreed to handle the collection's administrative affairs; these developments further sharpened the foundation's commitment to contemporary American art.[5]

Within a year, the new board approved the first of several "official" directions.[6] Since a concern with form and craftsmanship characterized many of the works the foundation had already bought, Goodrich suggested that aesthetic form rather than stylistic or thematic concerns serve as the guiding criterion for future purchases. He recognized the difficulties inherent in attempting to define form:

> In the past, form has been defined in many terms: clarity, precision, substance, sculptural roundness, three-dimensional depth, linear probity, subordination of color to form, traditional design in the Renaissance or Baroque sense, naturalistic as opposed to abstract form, etc. All such specific definitions, while describing certain of its historic attributes, tend to limit the concept of form in the world today. A broader contemporary definition might be that form is the fundamental structure, energy, movement and design of the work of art, as distinguished from its more decorative or subjectively expressive qualities. In this sense, form exists today in art of many different viewpoints and styles: not only in traditional or representational art but in abstract, semi-abstract and expressionist art.[7]

Roby and the other board members applauded Goodrich's attempt to give the foundation's efforts more focus, and enthusiastically embraced his definition. Foundation member Isabel Bishop wrote to Goodrich that a painting under consideration for purchase was "beautifully wrought . . . expressive . . . [and] of a passionately felt content. . . ." It did not, however, "possess form, in the essential sense of aesthetic unity," and therefore, Bishop concluded, should not be acquired.

By 1959 the collection had grown to significant size and stature, warranting a national tour and catalogue. *The Sara Roby Foundation Collection* opened at the Whitney in April and circulated for two years throughout the United States to enthusiastic reviews. With the scheduling of a second major tour—this time through Central and South America under the auspices of the U.S. Information Agency— the Sara Roby Foundation launched an ambitious exhibition program that continued into the 1980s.[8]

Despite these auspicious successes,[9] the 1960s were difficult years for the foundation. The collection presented an impressive array of art not only by leading artists, but by younger Americans as well—an expansiveness made possible during the 1950s by Roby's willingness personally to provide whatever funds were needed for the foundation's activities. But the inflating art market, even for recent American art,

coupled with fluctuations in the stock market, had depleted foundation resources to the point where major acquisitions began to seem impossible without a serious infusion of money. Whether the collection could continue to grow substantially along earlier lines seemed doubtful.

Various alternatives were proposed. The idea of collecting in the new and innovative, yet still inexpensive, field of American ceramics was rejected because of the difficulties inherent in touring such physically fragile works. A second suggestion, to acquire drawings and small sculpture, received enthusiastic approval by the board, and an ambitious list of artists was compiled. From a group of fifty, the board selected seventeen for more concentrated attention, among them Josef Albers, Leonard Baskin, Peter Blume, Sidney Goodman, Edward Hopper, Jasper Johns, Robert Rauschenberg, and Larry Rivers.[10] Yet in spite of optimistic intentions, the foundation acquired only a handful of new pieces during the 1960s.

In the late 1960s the Whitney's active schedule made administering the foundation an increasingly burdensome task and one that no longer dovetailed with the museum's own programs. The American Federation of Arts, which in 1967 had arranged a touring exhibition of the Roby collection and produced an up-to-date catalogue, assumed administrative responsibilities in 1970. Financial difficulties were largely resolved, and with the election of several new board members and the able assistance of A.F.A.'s coordinator of loans, Konrad G. Kuchel, the collection took on new dimensions.[11]

Until that time, many works in the Roby collection (including those by younger artists) reflected stylistic developments of earlier decades. Hopper, Evergood, Tooker, Bloom, and many others in the collection had matured artistically during the Depression years, and even though the foundation often purchased these artists' later works, they tended to embody the sensibility of an earlier era.[12]

Increasingly during the 1970s, there is a quality of innovation and stylistic invention to many of the foundation's purchases. Jack Beal's *Figure in Black Tights*, a formal tour de force in which the picture plane is manipulated to compel contact between subject and audience, and Roy De Forest's *The Real Inside Story*, with its funky overlay of dogs, people, and pieces of landscape, indicate the continued breadth of Roby's stylistic curiosity. As in the 1950s, Roby did not shy away from powerful, sometimes horrific, subject matter. Nancy Grossman's drawing of a shackled figure and her mask-imprisoned head, *Cob I*, both concern the repression of the individual psyche and serve as counterparts to the societal angst of Robert Vickrey's *Fear*.[13] In Charles Wells's strange *Sawney Bean IV*, a 1970 purchase,

flayed human forms hang suspended from meat hooks. The image is drawn from Roberto Lerici's dramatic adaptation of a Scottish folk tale, the story of the cannibalistic Bean family who preyed on wayfarers along a rural road.[14]

In recent purchases the foundation has remained committed to craftsmanship and increasingly to realism in one guise or another. Bruce Kurland's haunting *Bone, Cup and Crab Apple* in technique resembles the eighteenth-century European prototypes that inspired him. A fascinating companion to Cadmus's *Green Still Life*, Kurland's tiny painting is a clearly innovative composition that introduces issues of formal balance and tension unthinkable thirty years earlier. Roby also searched for paintings and sculpture that use realist pictorial devices to express mystery, humor, or other psychological or social themes or to explore provocative formal concerns. The precision of Alan Feltus's *August 1983*, the subtle suffusion of light in landscapes by Wolf Kahn and Robert Birmelin, the surreal spatial manipulation of Ben Kamihira's *Tree in the Square*, and the dry humor of William King's *Connoisseur* and Richard Merkin's *Madame Bricktop Sees St. Martin Go through the Room* are testaments to the thematic vitality and stylistic diversity of the contemporary realist mode.

Since its inception the foundation had reserved the option to dispose of works for such purposes as upgrading the collection and raising funds. In the 1950s, sculpture by José de Creeft and Louise Nevelson and paintings by George Tooker and John Heliker were traded for examples of these artists' work that were more in line with the foundation's directions.[15] In the 1960s the board approved the sale of Andrew Wyeth's *Blue Box* and a painting by Edward Hopper, although no action was taken at that time.

In the late 1970s, with available purchase funds again tight, the foundation continued to make good on its dual commitment to the support of young artists and the purchase of outstanding works by well-established figures. Hopper's *Lee Shore*, the Wyeth watercolor, works by Edwin Dickinson, Walter Murch, and Charles Sheeler, as well as the Old Masters remaining in the collection, were all sold to provide additional acquisition money.[16] A year-round resident of Nantucket at the time of her death in March of 1986, Roby used these funds to purchase works by several young artists she discovered on the island as well as to add new sculpture by William King and Harold Tovish and Raphael Soyer's beautiful *Annunciation* to the foundation's rich array of recent work.

The Sara Roby Foundation Collection has been variously described as realist, surrealist, individualist. It is realist in its predilection for figurative art, and surrealist in the frequency with which psycho-

logically motivated themes and subjective visions have been purchased. Without attempting to be comprehensive, the collection reveals points of contact and lines of divergence between new realism and earlier types of representational art and indicates the ongoing vitality of form. And this is its strength. The wit, lyric beauty, social concern, and probing formal issues that have long concerned American artists continue to thrive within the Sara Roby Foundation Collection.

NOTES

1. Letter dated 10 July 1986 from Lloyd Goodrich to the author.
2. Unless otherwise indicated, information and quotations about the Sara Roby Foundation Collection come from the organization's files, now at the National Museum of American Art, Smithsonian Institution, Washington, D.C.
3. Over the years the foundation has received frequent requests from artists seeking grants. With very few exceptions, however, these have been denied, although the foundation has often donated funds for various educational activities at museums, community centers, and art schools and helped finance David Sutherland's 1984 film, *Paul Cadmus: Enfant Terrible at 80*.
4. Faced with the enthusiasm over action painting, a number of representational painters, including Roby artists Isabel Bishop, Philip Evergood, Edward Hopper, Karl Knaths, Yasuo Kuniyoshi, Jacob Lawrence, Jack Levine, Oronzio Maldarelli, Reginald Marsh, Honoré Sharrer, Raphael Soyer, and William Thon, banded together in 1953 and published several issues of a magazine called *Reality: A Journal of Artists' Opinions* to reaffirm the validity of representational art. They reconciled their lack of stylistic or thematic unanimity by calling for the continued appreciation of human content in art.
5. In addition to Lloyd Goodrich, Hermon More, then director of the Whitney, Flora Whitney Miller, a trustee of the Whitney, and painter Isabel Bishop joined the foundation's board. Henry Schnakenberg, another artist, attended several board meetings and was informally affiliated from 1955 until about 1958. The Whitney's role involved all administrative responsibilities for the collection, including overseeing conservation, framing, loan requests, shipping, storage, and assembling works for the board's consideration.
6. Decisions were at times short-lived, however, because policy was made simply by vote among the board members who could alter or reverse decisions from one meeting to the next.
7. For a more detailed discussion of Goodrich's ideas on form see Lloyd Goodrich, "The Sara Roby Foundation Collection" in *The Collection of the Sara Roby Foundation* (New York: Whitney Museum of American Art, 1959), and also his "Form and Image," *Art in America* 48 (Spring 1960):20-21.
8. Between January 1960 and March 1962 the collection traveled to the Currier Gallery of Art, Manchester, New Hampshire; the Cleveland Museum of Art; the City Art Museum of St. Louis; the John Herron Art Institute in Indianapolis; the Dallas Museum of Fine Arts; the Seattle Art Museum; the San Francisco Museum of Art; the Santa Barbara Museum of Art; the Museum of Fine Arts, Houston; the University of Texas Art Museum, Austin; the Isaac Delgado Museum of Art, New Orleans; and the Oklahoma Art Center, Oklahoma City. The Latin American tour from May 1962 until July 1963 also included stops in San José, Mexico City, Guadalajara, Monterrey, Santo Domingo, Caracas, Guatemala City, Lima, Santiago, Buenos Aires, and Montevideo.
9. In addition to its exposure via numerous loans of individual objects, the foundation collection was shown at the Goddard Riverside Community Center, New York, in April 1965; at the Art School of the University of Hartford, Connecticut, in March 1966; and from September 1967 until December 1970 under the auspices of the American Federation of Arts in Reading and Newcastle, Pennsylvania; Louisville, Kentucky; Athens, Georgia; Fort Lauderdale, Tampa, and Miami, Florida; Huntington and Ithaca, New York; Akron, Ohio; Greenville, South Carolina; Chattanooga, Tennessee; Charlestown, West Virginia; and Calgary, Alberta.
10. The others were Harold Altman, Charles Cajori, Carmen Cicero, Edwin Dickinson, Jimmy Ernst, John Heliker, Walter Murch, George Ortman, and Gabor Peterdi.
11. In addition to Mrs. Roby, Lloyd Goodrich, and Isabel Bishop, board members were

Roy Moyer, director of the American Federation of Arts, and his successor, Wilder Green, art historian Barbara Novak, and lawyer/collector Asbjorn Lunde. Paul Cummings later joined the group. In the early 1970s, sculpture from the collection was shown at the Akron Art Institute, the J. B. Speed Art Museum in Louisville, and at the University of Georgia in Athens. American Federation of Arts touring exhibitions included *Realism and Surrealism in American Art from the Sara Roby Foundation Collection* (1971–1975) and *Americans: Individualists at Work from the Sara Roby Foundation Collection* (1972–1974). A small selection of works from the collection was featured at the Main Street Gallery in Nantucket in May and June of 1972 and 1973; *Recent Additions to the Sara Roby Foundation Collection* was shown at Goddard Riverside Community Center in April 1974; the Grey Art Gallery at New York University exhibited the collection under the title *Aspects of American Realism* in February and March 1976 and published a catalogue with that title. From 1978 on, exhibitors tailored shows to local needs and interests, rather than presenting preselected exhibitions. Under this program works from the collection were exhibited at Cornell University; the University of New York at Binghamton; the Danforth Museum in Framingham, Massachusetts; the Berkshire Museum; the Fort Wayne Museum of Art; the Owensboro Museum of Fine Arts, Kentucky; the Mary and Leigh Block Gallery, Northwestern University, Evanston, Illinois; the Cedar Rapids Museum of Art, the Alexandria Museum and Visual Arts Center, Louisiana, and the Huntsville Museum of Art, Alabama. The Fair Street Museum in Nantucket held special exhibitions from the collection in 1980 and 1984. The Museum of Art in Albany, Georgia, featured a selection of approximately a hundred works during the spring and summer of 1985, and the Museum of Art in Huntington, West Virginia, exhibited a second selection of similar size in late 1985. From 1 February to 27 April 1986, *American Figurative Painting Since 1950: Selections from the Sara Roby Foundation Collection* was on view at the North Carolina Museum of Art in Raleigh.

12. For example, Philip Evergood's 1952 *Dowager in a Wheelchair* reflects the concern with social issues that characterized his work during the 1930s. In response to a questionnaire about the painting Evergood wrote (31 July 1958): "Once I saw a tragic old-lady being wheeled on Madison Avenue. She was *alive in spirit* but her body was only half functioning. She wanted still to be young. A young, gentle fascinatingly fresh companion was wheeling her. As I passed, spring was in the air, a delicate whiff of lilac perfume mixed with a faint background of crushed rose petals reached my nostrils & then my brain. I was disturbed. I stopped when they'd passed and followed their progress through the crowds with my eyes. Taxis & cars were too noisy. I lost sight of them in a few moments. I went sadly on my way with a vivid memory which lingered on. I consider the painting to be one of the very best I ever painted."

13. Vickrey wrote: "Some artists today feel they must express their contempt of society by painting harsh, ugly, photographic paintings. I don't think a painting need be ugly to express a strong indictment. In this painting [*Fear*], for example, the shimmering effects produced by egg tempera strengthen, rather than detract from, the image of a nun fleeing the rubble and erosion of contemporary civilization." (Robert Vickrey and Diane Cochrane, *New Techniques in Egg Tempera*, New York: Watson-Guptill Publications, 1973, 17.)

14. Roberto Lerici, *La storia di Sawney Bean*, Milan: Lerici editori, 1964.

15. De Creeft's *Young Woman* and *Feminine Forms* were exchanged for his *Continuité*; Nevelson's *Cathedral* for *Sky Totems*; Tooker's *Sleepers* for *In the Summerhouse*; and Heliker's *White Rocks, Nova Scotia* for *The Howard House*.

16. Lyonel Feininger's *Clippers* was donated to the Whitney's building fund auction in 1966, and in 1984 Elie Nadelman's *Sur la Plage* was presented to the Whitney in honor of Lloyd Goodrich and in recognition of his and the Whitney's important contributions to the foundation's activities.

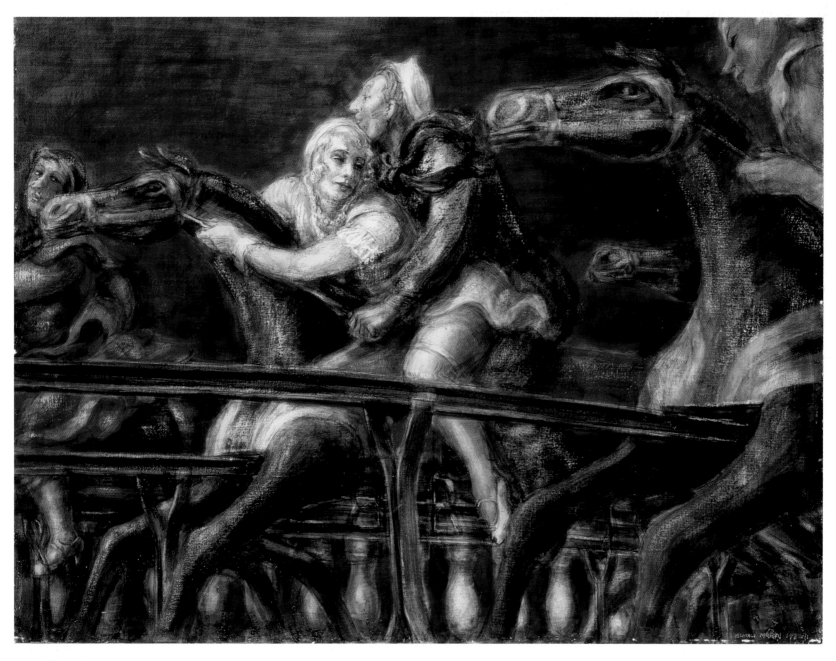

Reginald Marsh, *George Tilyou's Steeplechase*

The Sara Roby Foundation Collection: Varieties of American Realism

WILLIAM KLOSS

During the 1950s, with Abstract Expressionism the ascendant force in American art, painters like Jackson Pollock, Willem de Kooning, and Mark Rothko captured the attention of America and its art critics. Yet in 1952—in what may be regarded as a bold, even quixotic act, but ultimately a prescient one—artist and collector Sara Roby started a foundation with a decided preference for representational art. The foundation, which systematized Roby's previously casual collecting efforts, made an eloquent case for realism in an era of abstraction.

That case was founded upon the traditional artistic values, in particular realistic representation, that Roby absorbed during her long association at the Art Students League with Reginald Marsh and Kenneth Hayes Miller. From them she acquired an unshakable admiration for traditional technical and compositional principles. Miller instilled in his students a sense of dedication to art and pride in being an artist. Although he insisted on methods derived from the Renaissance, he did not chain his students to them: "Do what you do well, not what you admire," he told them.[1] This combination of traditional concerns with an openness of taste guided Sara Roby's experiments in collecting.

Realist art was neglected during the post-war years. Since the mid 1970s, however, interest in realism has been on the rise, and the very notion behind the avant-garde has been called into question: "the whole idea of 'advancing' belongs to a more optimistic age. Modern man is a sandcrab, moving sideways instead of straight ahead; he doesn't advance, he shifts."[2]

This reawakening of interest in realism has validated the significance of the Sara Roby Foundation Collection, a group of 176 works by 110 artists that spans more than sixty years of American art after World War I. The collection includes outstanding examples of many kinds of realism—psychological, socio-political, spiritual, and satirical, with surrealism and magic realism showing up as well. As such it offers a rare opportunity to consider the variety and vitality of modern American realism.

Although the foundation collected only American art, no narrowly partisan attitudes restricted its focus. The collection, in fact, reflects a deep respect not only for the European borrowings that characterized much American work after the turn of the century, but for the formal, social, and humanistic contributions made by immigrant artists as well.

The work of Guy Pène du Bois, an American who resided in Paris for many years, bears the mark of European influence. Although the spiritual isolation of the individual is an ongoing theme in American painting that finds a striking voice in his *Shovel Hats* (1923), Pène du Bois uses a stylistic language learned from French art to achieve an extraordinary balance between topical satire and eerie permanence. The fashionable clothes of the moment are draped on mannequinlike figures whose expressions border on, but evade, caricature to suggest alien, dislocated beings.

Of the same generation as Pène du Bois, Hugo Robus studied in France with Antoine Bourdelle just before the war. He responded to the lithe, smooth figures of Bourdelle's late style. Robus's 1934 bronze *One and Another* is a complex emotional work which, through an inventive pose, projects almost visceral feelings of birthing and protecting, combined with fear, even grief.

The contributions of the immigrants left a particularly strong mark on American artists. Arriving with his family from Russia in 1912, Raphael Soyer was one of a large number of foreign artists who settled in the United States between 1890 and World War I, and

whose influence profoundly altered the course of American art. Soyer's *Annunciation* (1980) embodies the humanistic underpinnings of the collection and its ongoing commitment to realism. It is a work that, except for the old artist's absolute mastery, might be mistaken for one of his youthful paintings. His figurative style, unimpeded (though not unaffected) by the passage of time, continues steadfast in its affirmation of the humanistic values of realist art. No American artist of this century has more consistently explored the human condition through the figure than Raphael Soyer.

Annunciation is not merely a realistic painting depicting two women, it is also a mysterious and suggestive work. It is a concentrated image whose melancholy essence not only pervades the carefully limited space, but suggests as well the sense of religious significance implied by the title. Soyer's painting resonates with unexplained mysteries. This is the kind of realism whose psychological component cuts deep. Psychologically charged realism, in a number of different guises, is the hallmark of a great many works in the Sara Roby collection.

Another immigrant, Gaston Lachaise, successfully intermingled styles he learned in Europe with those discovered in the United States. Lachaise, who arrived at the age of twenty-three in 1906, emigrated from France for an entirely personal reason, his love for Isabel Dutaud Nagle. A Canadian-born Bostonian, Isabel Nagle Lachaise served as the artist's frequent model, and it is her features that are idealized in *Head of a Woman* (1923). The stark surfaces and expressive linearity of this bronze reflect the influence of Paul Manship, the American sculptor whose chief assistant Lachaise became in 1913 in New York. But the bust can also be compared with the tiny cameo heads of jeweler René Lalique, for whom Lachaise worked in 1905. Its classic simplicity further calls to mind the smoothly honed wooden figures of Elie Nadelman, who arrived in New York from Poland in 1914, as well as the nearly abstract sculptures of Constantin Brancusi exhibited in the 1913 Armory Show. This rich mixture of sources suggests the delicate balance between representational and abstract modes that characterized European art in the second decade of the twentieth century, and which was imported to America through emigration and exhibition.

In the same year that Lachaise moved to Boston, Yasuo Kuniyoshi emigrated from Japan to Los Angeles to escape the Russo-Japanese war. Settling in New York in 1910, he soon came under the influence of Robert Henri's urban naturalism, followed by four years of study with Kenneth Hayes Miller. As with Lachaise, the crosscurrents of influence on the young artist were varied. In *Strong Woman and*

Child (1925), the portentous bulk of the figures suggests Picasso's ponderous neoclassical women. The small, unspeaking mouths and enormous, almond-shaped eyes with unfocused pupils resemble the heads in Heinrich Campendonk's German Expressionist woodcuts.[3]

The presence of an Asian and a European artist in New York shortly before World War I is more than just an example of the unprecedented immigration of artists to the United States. It is a symbol of the creative ferment that the meshing of cultures, stylistic differences, and opposing notions of reality would give rise to.

From John Singleton Copley on, American artists have reveled in lucid, descriptive, expressive realism—of the kind that leaves no wrinkle unexplored, no contour undelineated. It is often thought that this realism had no particular social or political implications. But in certain works by William Sidney Mount or George Caleb Bingham one clearly finds social commentary, including references to the disenfranchisement of blacks and women in American life. Later, the social sensitivity of the American artist is often implicit—for example, the profound sense of post-Civil War malaise in Winslow Homer's rural meditations.

Socialist thought had entered American intellectual and political life with the arrival of European immigrants, especially after the European revolutions of 1848, with each group bringing its own brand of ideology or aspiration. Despite the failure of American socialist political groups to find widespread popular support, there were indications of a general desire to improve the public welfare, as the fame of Upton Sinclair's *The Jungle* (1906) and his subsequent socialist novels made clear. The so-called Ash Can School of realism, which owed so much to the palette and honest vision of Thomas Eakins, gained notoriety through an indelicate predilection for the seamier side of the city and its less fortunate citizens. This choice of subject matter reflected deep-seated sympathy with leftist social and political attitudes, yet the Ash Can artists tended to sentimentalize poverty and glamorize such entertainments as sport and burlesque. The paintings of John Sloan and Robert Henri are more like picaresque novellas than social tracts. The American experience of World War I and the Great Depression a decade later seemed to impel many realist artists to address political realities.

In times of social dislocation and distress, realism as an expressive mode gains impetus, perhaps because of the empathy between the viewer and the representation of the world he knows too well—as though intensive looking at the offending reality could alter it. During

16

the period between the wars, social realism was decidedly the most widely practiced and critically approved mode, reinforced by the patronage of federal art relief agencies such as the Works Progress Administration's Federal Art Project (WPA/FAP).

Reginald Marsh, good friend and mentor of Sara Roby, was the paradigm of the thirties artist. At the urging of Kenneth Hayes Miller, he exercised his affinity for Ash Can subject matter and concentrated his attention on New York subjects, from the Bowery to Coney Island, and portrayed that city during the Depression with a vividness aided by his long experience as an illustrator. Although Marsh sometimes prodded the social conscience of his viewers, he more typically depicted abandonment to the sensual pleasures afforded by popular entertainments and recreations. The nested bodies of the sailor and the girl on the mechanical horse in *George Tilyou's Steeplechase* (1932) still radiate a good deal of heat fifty years later, although the lingering melancholy in the young woman's expression signals the transience of their pleasure.

Isabel Bishop had also been influenced by Miller and is in some ways close to Marsh, but her temperament is more intense and private. Her thinly painted *Artist's Table* (1931) is less a traditional still life, which tends to put objects at arm's length, than a summoning of the materials of the artist, an invocation of their potential. In *Mending* (1945) she discovers and captures, with the discernment and tact of a candid photographer, a poor man sewing his clothes while seated near a public fountain. The tremulous, vaporous, monochromatic surface, typical of Bishop by this time, preserves the privacy and dignity of the subject.

Although the federal art projects had provided a life line to a great many artists, the mural styles that many of them practiced in hundreds of public buildings under the government's aegis did not generally survive the war. A striking exception is *Tribute to the American Working People*, finished in 1951, by Honoré Desmond Sharrer. As a young woman Sharrer worked in California for the WPA/FAP, and in this ambitious painting, modeled after Renaissance polyptychs, she utilized the semi-narrative approach of muralists like Doris Lee and George Biddle. In her *Tribute*, Sharrer adapts the ancona or dossal format of thirteenth- and fourteenth-century Italian religious painting, in which the central space is occupied by a saint flanked by smaller scenes from his life. Sharrer's saint is the working man.[4]

At the opposite pole from Bishop's gentleness and Sharrer's elevation of the common individual are the vitriolic caricatures of the German painter George Grosz, who combined the non-realistic stylistic devices of Expressionism and Surrealism with the aims of social realism. Grosz immigrated to America in 1932 when it became clear that he and his work were unwelcome in Nazi Germany. His disturbing watercolor *A Hunger Fantasy* (ca. 1947) gives the measure of his bitter power. Ominous, biomorphic washes, which suggest Rorschach blots or the automatist drawings of André Masson, part to reveal a fat, drooling gnome with sausage nose jealously clutching wine and bread (or a wurst?) and holding some sagging edible impaled on a fork. This stomach-turning image is not about the hunger of the have-nots, but the gluttony of the haves.

While Grosz indicted individual avariciousness with a brush attuned to avant-garde stylistic devices, Jack Levine looked back in time for ways to express his social and political dissatisfactions. His satirical canvases are painted with a magical multifocus vision which has an effect like that of a microscope, isolating and objectifying the subject. Though his themes are American, when seen through his prismatic, time-warping surfaces his subjects seem of uncertain vintage. Levine is immersed in art history, and in *Inauguration* (1956–57) he seems to summon the shade of Vermeer—generally, in the sense of viewing the scene through a lens of some kind, and specifically, in the head of the woman with the broad-brimmed hat at the right.

Among the social realists who began working during the 1930s, Ben Shahn and Philip Evergood figure among the most politically outspoken, and the satirical, crusading spirit of their finest paintings (of which Shahn's series *The Passion of Sacco and Vanzetti* is the most famous) are often seen as typifying the period. But in truth the paintings of Shahn and Evergood, particularly those done after World War II, leave the viewer with the lasting impression that they are more concerned with the isolation of the individual in society and his dependence upon spiritual resilience for physical survival than they are with politics. It is this personal and psychological spirit that resides in the works by Shahn and Evergood in the Roby collection.

Evergood's *Dowager in a Wheelchair* (1952) captures the sad yet uplifting sight of an old woman who has survived another winter and who one last time holds center stage in the noisy city. The noise is sharply expressed by the strident yellow of the Checker cab, while the child who peers from its window joins us as witness and, at the same time, completes the generational circle. Shahn's 1959 tempera *After Titian* is indeed based on the Renaissance artist's late work, *Allegory of Prudence*. Both are mysterious paintings in which three juxtaposed male heads represent youth, maturity, and old age. Titian elaborated his meaning through inscriptions that personify past, present, and future. Shahn is more personal, less allegorical, and by adding the

suggestion of a torso and arms with folded hands on a foreground sill unites the three figures into a single image—the ages of *one* man.

During World War II the country seemed to turn away from its preoccupation with domestic problems, triggering a new internationalism that allowed American abstractionists to regroup and, with the impetus supplied by Europeans such as the Surrealists-in-exile, to push quickly ahead. In the late thirties, as Barbara Rose has written, "abstract art in America was a voice crying out in the wilderness."[5] Soon after the war's end, however, "Abstract Expressionism," as the new art was called, rapidly came to dominate the national art scene and became the first quintessentially American phenomenon to have an impact upon European artists of the same generation.

While Cubism and geometric idealism were at the root of prewar abstraction in the United States, the new abstraction drew inspiration from modern psychology and the growing awareness of the subconscious, a realm that had been publicly exploited first by the Surrealists (although it is latent in the psychologically charged realism of which we have spoken). The rise of Abstract Expressionism set the stage for the renewal of the abstraction/realism controversy in the 1950s.

Much of the angst and profound inwardness of Abstract Expressionism may be traced to the spiritual confusion generated by the war. It was hard to cling to Renaissance ideals of the perfectability or rationality of humanity in the aftermath of Hiroshima and the Holocaust. Some artists registered the cataclysm by violent changes in their styles. Theodore Roszak, for example, had expressed Utopian dreams in pure geometry in his constructions of the thirties. The war swept away his certainty and he responded with jagged, piercing bronzes, like *Thistle in the Dream (To Louis Sullivan)* (1955–56), aggressive-defensive totems for a violent world. But the war marked changes for realists as well. The same feelings of angst and dislocation that led Roszak to reject his past approach also guided Shahn's decision to put political considerations aside and pursue individual psychological concerns. At the same time, however, the realists with their humanistic themes seemed to assume an almost political stance, proudly asserting the continuity of their work with that of the past (Shahn's *After Titian* comes to mind again).

Paul Cadmus has been devoted to Italian Renaissance models and practices throughout his career, but is nonetheless fond of using them as ironic counterpoint to his psychologically charged contemporary subjects. A sojourn in Italy from 1952 to 1953 resulted in some of his best paintings, among them the mysterious *Night in Bologna* (1958). With Bologna's celebrated arcades for its setting, the painting offers an intriguing perspective on sexual hunger and loneliness. The soldier eyes the prostitute, she eyes the traveler, and the traveler eyes the soldier. Transitory lust is caught in a timeless environment, emotional need is parceled into architectural cells.[6]

Like Cadmus, George Tooker deals with human isolation, and no artist in the Roby collection creates a more profoundly spellbound, psychologically keyed world. Tooker learned egg tempera technique from Reginald Marsh and Paul Cadmus, and his exquisite use of the medium is ideally mated to his timeless, suspended imaginings. While he is best known for his expressions of alienation, *In the Summerhouse* (1958) is a lyrical utterance, poised in a dream of light and delicate shadow. The trellis of the summerhouse is at once an enclosure and a skeleton for the buoyant globes of the Japanese lanterns which, almost imperceptibly held by the girls, seem rather to rise silently across the picture like hot air balloons. The motionless poses of the girls, together with the aureoles of soft, ethereal light, suggest the angelic.

The element of the mysterious, even the disturbing, that is so often found in work collected by the Roby foundation seems to be especially prominent in the more recent additions to the collection. Nancy Grossman's 5 *Strap 1*, a 1968 pen-and-ink drawing, and *Cob I*, a wood and leather piece (1977–80), both represent heads encased in fetishistic leather hoods with sadomasochistic overtones. That they may also be commentaries on the dehumanization of the contemporary world does nothing to alleviate the black spell they cast.

The insistence on humanistic or psychologically charged thematic concerns that characterizes so much of the Roby collection's figurative compositions is found in the landscapes as well, which is not surprising given the introspective nature of many American landscape paintings, from the nineteenth century to the present. Although Regionalist landscape painting dominated the scene between the wars, in the forties landscape painting was increasingly neglected by most major American artists and was then displaced, even subsumed, by abstract painters. Among the great exceptions to this statement are Edward Hopper and Charles Burchfield.

Starting in 1930, Hopper and his wife summered on Cape Cod, and the sun-bleached sparseness of that shifting landscape of dunes conditioned some of his most memorable paintings. *Cape Cod Morning* (1950) is one of the treasures of the Roby collection. The angular house is thrust into the soft landscape like a ship's prow, an alien presence stubbornly imposed. The figure of the woman in the bay

window suggests containment and isolation, yet she looks out with an intentness matched by ours, as we look at her. The morning light underscores the mood as the woman, watchful and tense, peers out at the day more with apprehension than anticipation. This stringently edited world combines peaceful order and restrained anxiety in equal measure.

One of the most original of American modern artists was Charles Burchfield. He literally brought a new dimension to watercolor by increasing the size of the image, sometimes by starting large, but sometimes by revising a composition after a period of many years and adding paper to enlarge the field. In the latter case the date inscribed on the final state reflects this process, as in *Night of the Equinox*, dated 1917–1955. This 40-by-52-inch landscape is a haunting summation of his mystical union with nature and suggests that Burchfield shared the age-old belief that the vernal equinox brought about an upheaval in nature. Burchfield's obsession with the rhapsodic visions of his childhood constitutes the foundation and source of his art. Every later experience of nature was related to the nature-inspired fantasies of his boyhood years.

Burchfield's sense of unseen forces working their powers on the world has a contemporary counterpoint in Gregory Gillespie's tiny, compulsive-obsessive *Landscape with Perspective* (1975), in which the "perspective" fights a losing struggle with the tilting, rising picture plane. Melting and metamorphosing forms attract and repel in just the fashion of Bosch's scenes of hell. Pulled in by the meticulous detail and richly rendered surface, the viewer retreats in the face of incipient violence combined with sexual innuendo and the threatened emergence of monstrous images.

On a calmer yet equally mysterious note, Ben Kamihira's *Tree in the Square* (1970), a painting as memorable as it is unclassifiable, combines architecture, a tree, and figures in a montage with no spatial or rational logic. Despite the dreamy nostalgia, the painting is built with gridlike authority; and the disquieting aura of the mauve shadows and oblique imagery is lightened by the witty graffito of the tree's trunk and roots chalked on the wall.

In an acute analysis of "culture as nature," Robert Hughes has remarked:

> Until about fifty years ago, images of Nature were the keys to feeling in art. . . . The sense of a natural order, always in some way correcting the pretensions of the Self, gave mode and measure to pre-modern art. If this sense has now become dimmed, it is partly because for most people Nature has been replaced by the culture of congestion: of cities and mass media.[7]

Many of the Roby collection landscapes avoid congestion. Perhaps because Sara Roby escaped New York to summer in Nantucket, her year-round home late in her life, where nature's forms are disposed in the simplest fashion, her taste in painted landscape favored clear, taut compositions.

Wolf Kahn's *High Summer* (1972) is a fine example of this taste. The sloping barn meets and merges with the hill in a passage of bold complexity. The brushwork in the trees and grasses is reminiscent of Hopper, but the vivid orange and yellow in the palette have a stirring immediacy quite different from the cool reticence of the older painter. Robert Birmelin's open and extensive *Dalles Dam* (1975) avoids the lushness of Kahn while echoing the reductive simplicity of form in Hopper.

The same strong, simple aesthetic is evident in Keith McDaniel's *Fort Warren* (1981). This complex interior of lights and darks is stark, but not cold. Once more Hopper comes to mind in the way McDaniel invests his dark doors and light windows with presence, with personality. It is an exercise in subtle geometry that also suggests a colloquy among its inanimate components.[8]

Since the sixties were dominated by Pop artists and by their immediate precursors, Robert Rauschenberg and Jasper Johns, it is at first surprising that the Roby collection ignores them. Pop Art surely is concerned with a species of realism; indeed, it may be called the genre painting of the decade. Its spirit of detachment is a quality Pop shares with much of the work in the Roby collection. Yet it appears that Sara Roby had little interest in collecting this work. Perhaps it was the public nature of Pop that she shied away from. Its recurrent billboard scale, references to mass media techniques, and deadpan literalness all tend to remove the painting a step further from the actual referent and make it not an imitation of an object but an imitation of an imitation.

The Roby collection, however, does include two important paintings of the sixties by Will Barnet and Jack Beal. Barnet's *Sleeping Child* (1961) is superbly balanced, both between realism and abstraction and between humanism and objectivity. The adjustment of the figure group to the frame in this large canvas is a matter of the most exquisite sensibility, aligned in unison at the top and at the horizontal crossing, yet with curves at gentle variance at every point. Jack Beal's *Figure in Black Tights* (1967), another large picture, is more complex. Setting up an ambiguous space, in which the brilliantly lit inflatable mattress or beach raft is placed in such contrast to the dark, draped deck chair

that the eye tends to jump over the reclining woman, Beal not only contrasts negative and positive areas, but also flat and fully modeled forms. It is, in Barbara Rose's words, "as if Matisse had suddenly decided to repaint Courbet's subjects."[9]

One of the most startling of the Roby collection's more recent images is Roy De Forest's *The Real Inside Story* (1973). Although not unrelated to other currents of the seventies, De Forest's work stands out by virtue of its neo-primitivism in both style and content. Stylistically, the figures are depicted in pure profile, except for the small dog at the right which is seen head on, without foreshortening. Unmodeled, these figures are drawn pictographically, in the manner of the art of several ancient cultures. The confrontation of dog and pied horse, separated by the window of domestication; the staring but stone-still men and animals; the willfully crude, jarring patterns and colors of the house and landscape elements—all point to the artist's decision to redefine or realign in his work the relations between man, animal, and environment.

Whether announcing despair or affirmation, American realist art in the twentieth century is a persistent attempt to discover what position man occupies in a world he has brilliantly transformed but often seems unable to control. As seen in the Sara Roby Foundation Collection, realist art has a remarkable range of style and content. But whether linear or painterly, naturalistic or semi-abstract, or whether the subject is figure, object, or landscape, many of the Roby paintings and sculptures speak with one voice, in the accents of commitment to the humanistic tradition Sara Roby was taught to revere. It is a commitment that requires patience, the determination and faith to take the long view. That in turn requires pragmatism, a willingness to draw comfort from small as from large realities, from still life as from spiritual struggle.

NOTES

1. Lincoln Rothschild, *To Keep Art Alive: The Effort of Kenneth Hayes Miller, American Painter (1876–1952)* (Philadelphia: The Art Alliance Press, 1974), 57.
2. Ellen H. Johnson, *Modern Art and the Object* (New York: Harper and Row, 1976), 43.
3. Although many artists had drawn inspiration from primitive and folk art, in the case of Kuniyoshi, one need look no further than the art of his native Japan for convincing prototypes of these characteristics of style. The somewhat unearthly aura of *Strong Woman and Child* may thus relate as much to the austere calm of Asian art as to examples of folk or primitive art.
4. The unrealistic scale of the factory and the naive perspective of the buildings and interiors in the small panels are both derived from early Italian models, and the peaked gable of the factory above the worker's head is analogous to the shape of the central panel in many Italian polyptychs. This general idea is aptly demonstrated by two well-known thirteenth-century panels still in Italy: the St. Catherine Altarpiece in the museum in Pisa and the St. Francis Altarpiece in Santa Croce in Florence. See Ernest T. DeWald, *Italian Painting 1200–1600* (New York: Holt, Rinehart and Winston, 1961), 42, fig. 2.17 and 53, fig. 3.3.
5. Barbara Rose, *American Art Since 1900*, rev. ed. (New York: Praeger, 1975), 124.
6. This description, with some differences, appears in my text on Cadmus in *Treasures from the National Museum of American Art* (Washington and London: Smithsonian Institution Press, 1985), 242.
7. Robert Hughes, *The Shock of the New* (New York: Knopf, 1981), 324.
8. It is important not to confuse the clarity of McDaniel's or Birmelin's work with the meticulousness of the Photorealists who debuted in the seventies. Their compulsive, unemotional cataloguing of the (mostly urban) modern world is directly descended from the Pop artists and, like Pop, Photorealism finds no place in the Roby collection.
9. Rose, *American Art*, 238.

Catalogue

Dimensions are in inches, followed (in parentheses) by centimeters, with height preceding width and depth. Dimensions for works on paper indicate sheet size, and those for sculpture include bases when integral to the piece.

Provenances indicate previous owners, the gallery from which a work was purchased, and the date it was acquired by the Sara Roby Foundation.

Will Barnet
born 1911

Sleeping Child
1961

oil on canvas
62 x 48 (157.4 x 122)
provenance: Waddell & Grippi, New York, 1966

Between 1927 and 1930 Barnet studied at the
School of the Museum of Fine Arts in Boston,
and in the mid 1930s he taught in New York at
the Art Students League and the New School for
Social Research. Throughout his career Barnet
has been a figurative artist, although in the late
1940s he experimented with eliminating realistic
space and began using semi-abstract forms to
convey what he felt were substances and forces
in nature. In the mid 1950s, he reduced his
images to simple pictographs, although basic hu-
man shapes could still be discerned. Around
1960, however, he became dissatisfied with his
attempts to unite human and abstract forms, and
sought a fresh approach. Starting in 1962, when
he exhibited a new series of paintings that reas-
serted the human figure as his primary subject
matter, Barnet has continued to explore themes
of meditation and human relationships.

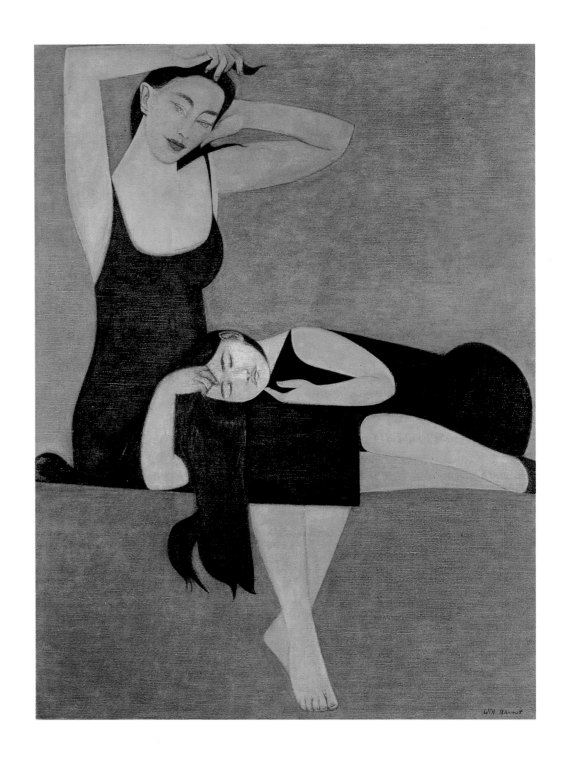

Jack Beal
born 1931

Figure in Black Tights
1967

oil on canvas
68 x 75 (172.5 x 190.5)
provenance: Allen Frumkin Gallery, New York,
1968

An Abstract Expressionist when he left the Art
Institute of Chicago in 1956, Beal has since
become a dedicated realist who sees art as a
potentially powerful moral force. He has great
regard for Platonic ideals of truth, beauty, and
goodness, and admires both the realism of seven-
teenth-century Dutch painting and the composi-
tional authority of Renaissance art. Since mov-
ing to New York in the late 1950s with his wife,
painter Sondra Freckelton, Beal has painted still
lifes, portraits, and landscapes, although in re-
cent years his most ambitious undertakings have
been large-scale allegories and myths. In describ-
ing his approach, Beal calls himself a "life
painter" and says he is committed to human
over aesthetic concerns. Yet his intricate com-
plexes of figures and surface patterns, along with
his adroit handling of space, reveal his sophisti-
cated, accomplished sense of composition.

Robert Beauchamp

1923–1995

Untitled

1972

charcoal, conté crayon, pen and ink, and pencil
on paper
36¼ x 79½ (92 x 203)
provenance: Dain Gallery, New York, 1972

Robert Beauchamp studied with Boardman
Robinson at the Colorado Springs Fine Arts
Center and attended Cranbrook Academy of Art
before working with Abstract Expressionist Hans
Hofmann. In 1953 he gave up abstract art,
believing it to be too esoteric and remote from
immediate life, and returned to painting the
figure. Beauchamp's approach, however, was to
"distort, fantasize and pile in the images . . . to
paint objects with the subtleties of natural forms
and the subjectivity possible through abstraction."
In the decades after he began exhibiting,
Beauchamp received several grants, traveled to
Rome on a Fulbright fellowship (1959), and held
several teaching positions. A New York resident
in his later years, Beauchamp exhibited regularly
and painted fanciful, sometimes horrific, scenes
in which "reality" provided as important a source
of inspiration as did the imagination.

Robert Birmelin
born 1933

Dalles Dam, Evening
1975
acrylic on canvas
33⅝ x 53½ (85.2 x 136)
provenance: Marilyn Pearl Gallery, New York,
1980

Birmelin attended the Cooper Union and Skow-hegan art schools and received B.F.A. and M.F.A. degrees from Yale University. A 1960 Fulbright grant followed by a Prix de Rome in 1961 enabled him to study for a year at the Slade School in London and to spend three years at the American Academy in Rome. A realist with a fascination for existentialist literature, Birmelin is perhaps best known today for his panic-tinged New York crowd scenes. He draws his imagery from the disparate environments of New York City, where he teaches, and his summer home on Deer Isle, Maine. Birmelin controls visual experience through viewpoint: the panoramic sweep of his light-suffused landscapes provides the serenity of distance, while in the crowd scenes he crops images and truncates people at picture edges to create an immediacy that perfectly coincides with the compelling urgency of his subjects.

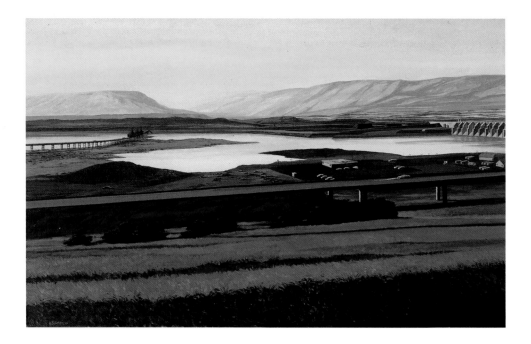

Isabel Bishop
1902–1988

Artist's Table

1931

oil on canvas
14⅝ x 17½ (37.2 x 44.5)
provenance: Midtown Galleries, New York, 1982

Hoping to become an illustrator, Bishop came to New York in 1918 and enrolled in the School of Applied Design for Women. In the early 1920s she transferred to the Art Students League to study painting with Kenneth Hayes Miller and Guy Pène du Bois. In 1934 she leased a studio at Union Square, where she observed and recorded the everyday activities of the derelicts and working-class people of the city. Subject matter was always important to Bishop, and she studied Mantegna, Piero della Francesca, and Chardin for their ideas of structure and composition. By the 1930s, her impeccably drawn figures brought Bishop recognition as one of the outstanding urban realists of the "Fourteenth Street School," a loosely affiliated group named for the area where Bishop, Reginald Marsh, and the Soyer brothers, among others, lived and portrayed the local scene. In later years Bishop turned from painting the female nude, a primary theme during the 1950s and 1960s, to portraying groups of figures in motion.

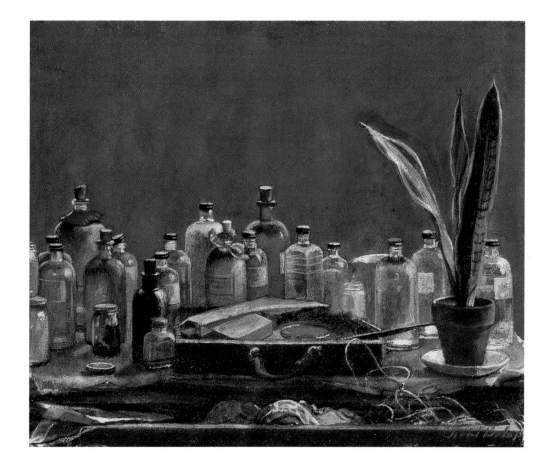

Arnold Bittleman
1933–1985

Diptych
1958

pen and India ink on paper
each panel: 40½ x 27⅝ (102.9 x 70.1)
provenance: Grace Borgenicht Gallery, Inc.,
New York, 1958

Throughout his life Arnold Bittleman was dedi-
cated to drawing. A student at the Rhode Island
School of Design in the early 1950s, Bittleman
received his B.F.A. degree from Yale University
then spent a year abroad on an Alice Kimball
English Traveling Fellowship before completing
his graduate work in New Haven. His deep re-
spect for Old Master draughtsmen—Leonardo,
Dürer, and Goya, among them—coupled with
the teachings of Josef Albers helped Bittleman
determine his future directions. Bittleman be-
lieved drawing to be a process of thought, and
not simply the transcription of observed im-
ages—a concept he pursued both as an artist and
as a teacher at various institutions (including
Yale, Minneapolis School of Art, and Union
College in Schenectady from 1966 until his
death).

Al Blaustein
born 1924

Family and Friends
1967

pen and ink and pencil on paper
8⅛ x 9⅞ (20.6 x 25)
provenance: Terry Dintenfass, Inc., New York,
1972

Known as a painter and printmaker, Al Blaustein
received his formal art training at Cooper Union
following three years of active military duty dur-
ing World War II. Commissions for *Life* maga-
zine and the British Overseas Food Corporation
in East Africa in 1948 and 1949, followed by a
three-year Prix de Rome fellowship and grants
from the American Academy of Arts and Letters
and the Guggenheim foundation, enabled Blau-
stein to travel extensively throughout the fifties.
In his early work Blaustein concentrated on tex-
ture and patterning and built compositions with
small, detailed elements, but broadened his ap-
proach after working on a mural in 1952. A
painter of landscapes, studio interiors, and figure
subjects, Blaustein seeks to reveal essentials and
is concerned less with specific information about
appearance and locale than with mood-evoking
contrasts of light and dark, form and line.

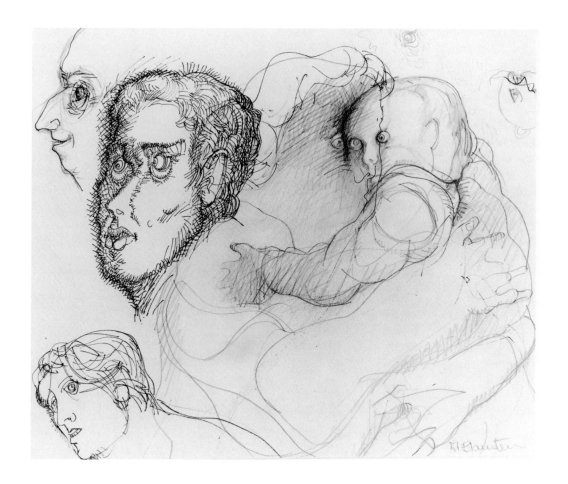

Hyman Bloom
born Lithuania 1913

The Beggar
1956

casein on paper
20¼ x 18¹⁄₁₆ (51.5 x 45.8)
provenance: Downtown Gallery, New York,
1957

Bloom and his parents immigrated to Boston from Brunoviski, Lithuania, following World War I. Bloom was a precocious draughtsman and, while still in high school, began studies with Harold Zimmerman at the West End Community Center where he met lifelong friend Jack Levine. Denman Ross, a color theorist and Harvard professor emeritus, took the young artists under his wing, rented a studio for them and provided small weekly allowances. During the 1930s, through intermittent employment on the WPA and support from several dealers, Bloom avoided the confines of a full-time job and, along with Levine and German-born Karl Zerbe, became known as a Boston Expressionist. Bloom is at heart a mystic and philosopher, a private individual intrigued by ideas of reincarnation, Jewish tradition, Eastern philosophy, and the occult. In his paintings, and in the drawings that occupied him primarily from the 1950s until the late 1970s, Bloom deals with themes of life and death and with human emotional conflict.

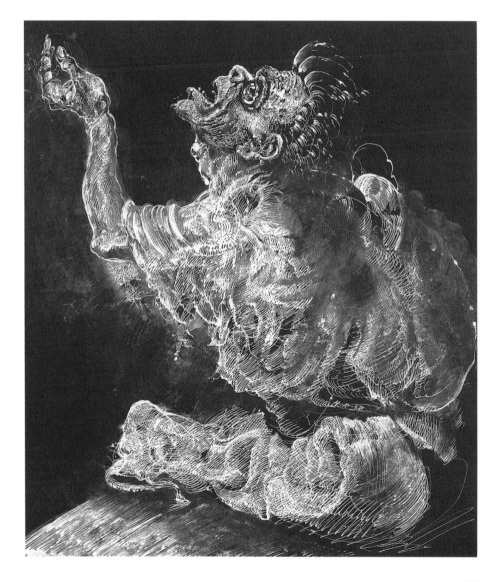

Peter Blume

1906 Russia–1992 USA

Nude

1957

brush and ink on paper
18½ x 12¹¹⁄₁₆ (47 x 32)
provenance: Durlacher Brothers, New York,
1958

A 1911 immigrant to the United States, Blume
studied at the Educational Alliance until 1921
and then at the Art Students League and the
Beaux-Arts Academy in New York. Following
brief jobs with a jewelry firm and a lithographic
and engraving company, he struck out on his own
in 1924, although he did agree to paint several
post office murals for the government during the
1930s. Blume's mature career stemmed from his
figurative paintings of the late 1920s, and
national recognition came in the 1930s with his
anti-Fascist work, *The Eternal City*. Although
often called a Magic Realist, Blume took his
imagery not from the domain of fantasy but from
a world of familiar objects and landscape features
forced into surreal relationships. Blume rendered
themes of human struggle and the decay of
values in scenes of meticulous detail, suggesting
psychological dislocation by dramatically altering
the relative scale of his subjects.

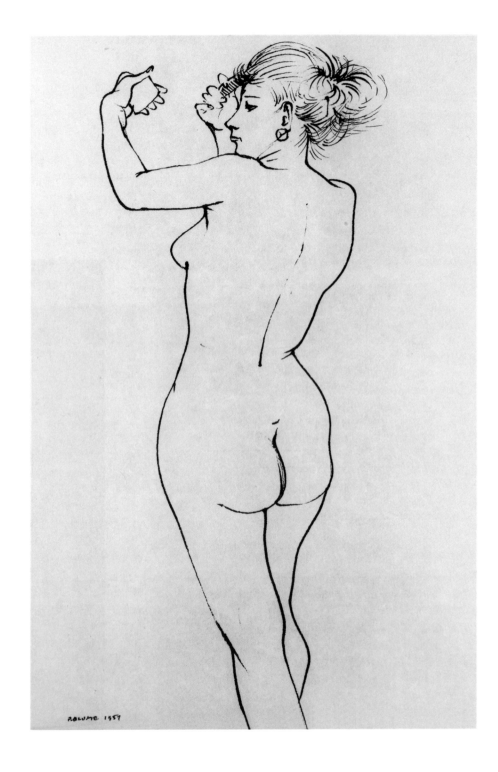

Robert Broderson
born 1920

By the Sea
1968

oil on canvas
60⅛ x 63⅜ (152.7 x 161)
provenance: Terry Dintenfass, Inc., New York,
1971

Broderson, who served in the Air Force during
World War II and later received grants from
Duke University (where he taught from 1957
until 1964), traveled widely throughout Europe,
Mexico, and Africa. A painter of figures in bleak
landscapes, Broderson pays little attention to the
specifics of place. His stark, often distorted, fig-
ures hold strange birds and beasts and are darkly
set against dramatically light skies. His images
are enigmatic and haunting, offering unlikely
symbolic connections that defy rational explana-
tion. Broderson executes his figural works with a
painterly freedom reminiscent of his early days as
an Abstract Expressionist.

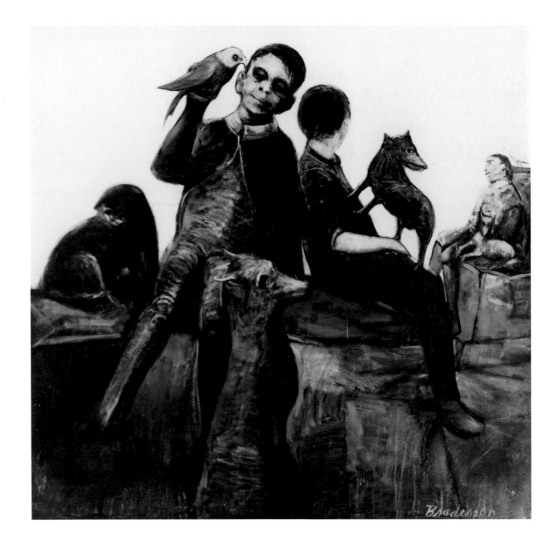

Charles Burchfield
1893–1967

Night of the Equinox
1917–55

watercolor, brush and ink, gouache, and charcoal on paper mounted on paperboard
40⅛ x 52³⁄₁₆ (102 x 132.5)
provenance: Frank K. M. Rehn Gallery, New York, 1956

After graduation from high school Burchfield won a scholarship to the Cleveland School of Art, where Henry G. Keller urged him to develop the personal style Burchfield later called "romantic fantasy." Most of Burchfield's early watercolors—he seldom painted in oil—are haunting scenes of nature in which graphic symbols become pictorial equivalents for feelings. After serving briefly in the army at the end of World War I, Burchfield found he had lost his romantic view of nature and turned during the twenties to increasingly realistic views of houses, streets, and industrial scenes that led critics to describe him as a midwestern Regionalist. Attempting to regain the intensely personal quality of his early work, in 1943 Burchfield again began painting the forces and mysterious presences of nature. He returned to watercolors done in his youth, reworking and enlarging them by adding sections of paper to the original sheets.

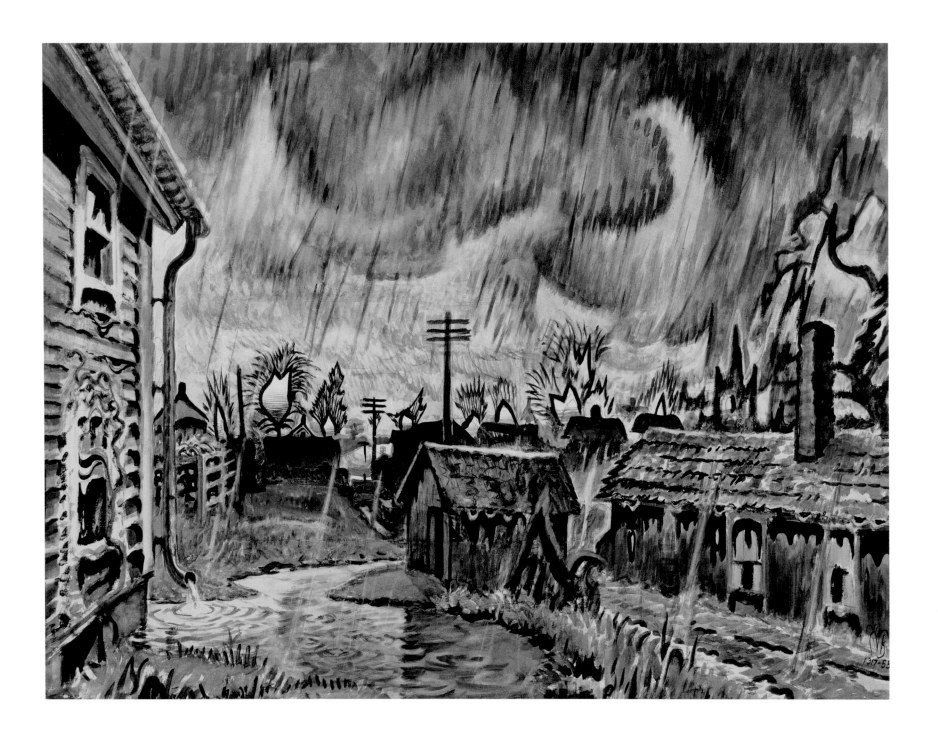

Paul Cadmus
born 1904

Night in Bologna
1958

egg tempera on fiberboard
50½ x 35⅛ (129 x 89)
provenance: Midtown Galleries, New York, 1958

Cadmus entered the school of the National
Academy of Design at fifteen with the encour-
agement of his parents, both of whom were art-
ists. In 1928 he began working as an illustrator
for a New York advertising agency and took life-
drawing classes at the Art Students League. In
1931 and 1932 Cadmus and his studio-mate
Jared French lived in a Mallorcan fishing vil-
lage. On their return Cadmus was employed on
the first of the New Deal art programs, and later
painted several post office murals under govern-
ment sponsorship. In conjunction with his first
one-man exhibition in 1937, Cadmus published
a credo (actually written by French) in which he
declared himself a satirical propagandist for the
correction of moral evils who used people's "sub-
versive, selfish and deadening expressions" to
convey humanity's "destructive malignity." His
subjects are often drawn from the seamy side of
life—his controversial *The Fleet's In* of 1934
showed sailors carousing with women of ques-
tionable morals—although in the late 1940s he
added lyrical and self-reflective themes to his
repertoire. Cadmus is a prolific draughtsman,
but because he has worked since the late 1930s
primarily in the time-consuming technique of
egg tempera, his output as a painter has been
relatively small.

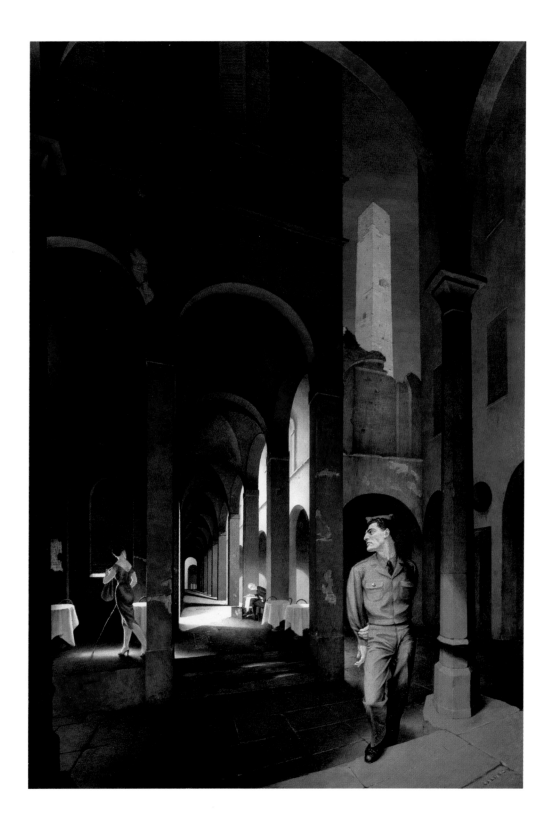

Paul Cadmus
Male Nude (#179)
1983

crayon and olive green acrylic on gray paper
24⅝ x 17¹¹⁄₁₆ (62.6 x 44.9)
provenance: Midtown Galleries, New York, 1984

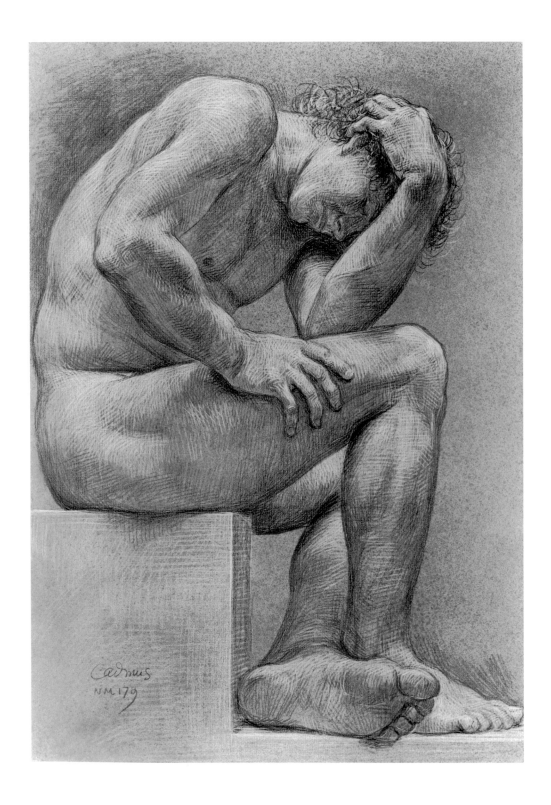

Kenneth Campbell
1913–1986

Nike
1964

Vermont gray marble
42 x 10¼ x 10 (106.7 x 26 x 25.4)
provenance: Grand Central Moderns, New York, 1966

An abstract painter with ties to Constructivism, Campbell turned to sculpture at age forty-one. His artistic training had ranged from academic to avant-garde, initially at Massachusetts School of Art in Boston, later with Leon Kroll and Gifford Beal at the National Academy of Design and at the Art Students League with then geometric abstractionist Vaclav Vytlacil. During World War II he worked as a machinist and mechanical designer. By 1954, having taken up direct carving, Campbell combined academic notions about three-dimensional form with a fascination for process that was typically Abstract Expressionist. Throughout the fifties he taught privately in his studio and did free-lance industrial design and model making, while developing a body of sculpture to be shown in his first solo exhibition at Camino Gallery in 1960. Campbell's teaching career included positions at Queens College, Silvermine College of Art in New Canaan, Connecticut, and the University of Maryland.

Paul Caranicas
born Greece 1946

Fort Tilden II
1979

pencil on paper
23¼ x 30⅝ (59.2 x 78)
provenance: Fischbach Gallery, New York, 1979

A graduate of Georgetown University, the Corcoran School of Art, the Ecole des Beaux-Arts, and the Art Students League, Caranicas brings formidable technical skill to haunting architectural subject matter. Though not a Photorealist, Caranicas works from photographs in painting the abandoned shells of World War II defensive bunkers along the French and U.S. coastlines and in the Channel Islands. In the rigorous linearity of the blocklike concrete shapes, Caranicas sees beautiful architectural structures that for him have political and intellectual, as well as aesthetic, implications. Caranicas sets the defense bunkers into landscapes purified to the point of surrealism, and in his most recent work, pieces together sheets of paper at geometrically irregular angles to further distort the appearance of reality.

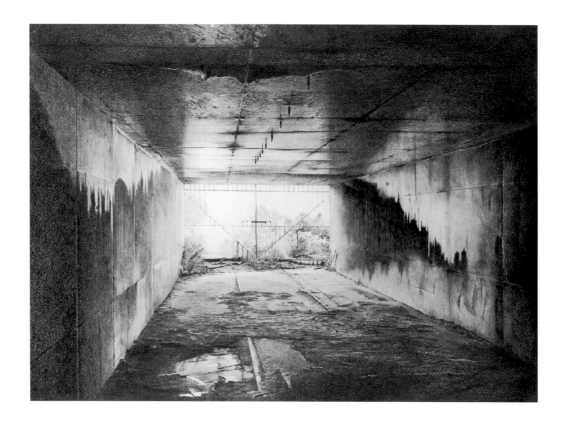

Wynn Chamberlain
born 1928

Interior: Late August
1955

egg tempera on fiberboard
23¼ x 16¼ (59 x 41.3)
provenance: Edwin Hewitt Gallery, New York,
1957

Wynn Chamberlain received an M.A. degree
from the University of Wisconsin in 1950 and
had his first solo exhibition in Milwaukee the
following year. Over the next ten years, Cham-
berlain painted highly detailed landscapes and
interior scenes, as well as allegories based on the
compositional formats of northern Renaissance
painting. The allegories are modern statements
on such portentous themes as the aftermath of
war, while the landscapes and interiors, which
frequently show isolated figures, deal with the
human condition in more personal terms. In the
1960s Chamberlain turned from representational
subjects to symbolic, gestural abstractions.

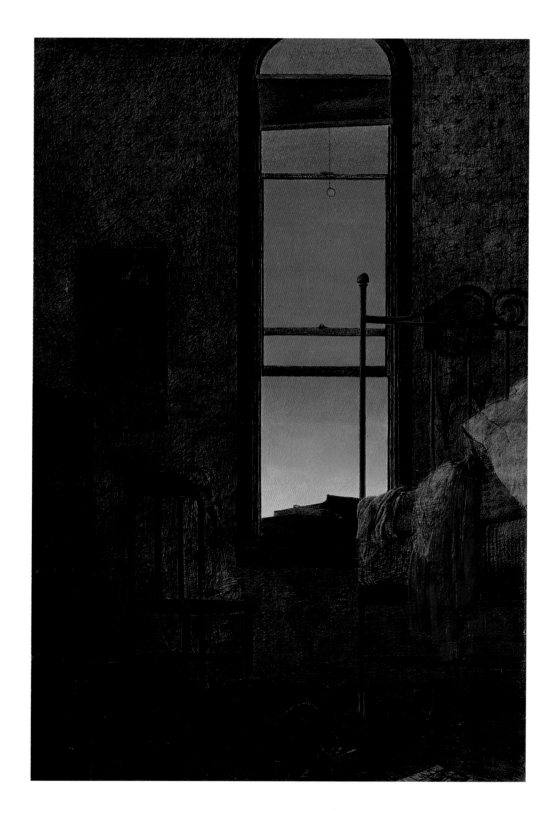

Saul Chase
born 1945

Two Forty-Seven P.M.
1970

acrylic on canvas
80 x 68 (203.2 x 172.7)
provenance: A.C.A. Galleries, New York, 1971

Chase graduated from City College of New York, where he also received his M.A. degree. He taught for six years in vocational schools before he had his first solo show at A.C.A. Galleries in 1973. A realist with a predilection for geometric abstraction, Chase works loosely from photographs, but dissects and reconstructs the buildings, store fronts, streets, bridges, and skies captured by his camera. Chase's urban landscapes are devoid of people and action and possess a precise linearity and atmospheric clarity that derive from the rectilinear planes and surfaces of his subjects. A great admirer of J. M. W. Turner, Chase describes his scenes as memories of visual events and says his goal in painting is ambiguity: "the multiple levels that paint can achieve."

Carmen Cicero
born 1926

Near Tibidabo
1958

oil on canvas
40¼ x 50⅛ (102.3 x 127.3)
provenance: Peridot Gallery, New York, 1960

Originally an abstract painter with ties to Surrealism, Cicero studied at Hunter College with Robert Motherwell and Hans Hofmann. During the 1950s he exhibited direct automatic drawings and abstractions based on his memories of places. In 1971, after a studio fire destroyed his entire body of work, Cicero was determined to begin anew. He moved from New Jersey into New York City and evolved a style dramatically different from that of his earlier years. Cicero now uses biting wit and figural distortion to create cartoonlike scenes that suggest states of mind or being rather than perceived reality. Although his new work is visually allied with Chicago Imagism of the 1970s and recent Neo-Expressionism, Cicero's roots as an artist go back to the beat generation and the work of such figures as James Dean and Jack Kerouac.

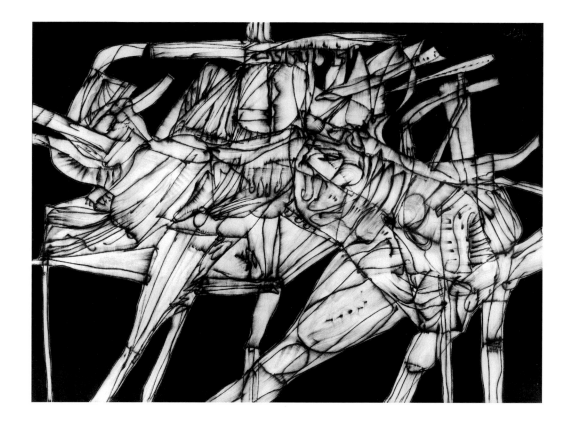

John Patrick Civitello
born 1939

The Family
1973
acrylic on canvas
72 x 84 (182.8 x 213.2)
provenance: A. M. Sachs Gallery, New York,
1974

Civitello graduated in 1961 from William Paterson College and received an M.A. degree from New York University. He then spent two years in Italy as a Prix de Rome winner. On his return, Civitello—struck by the industrial quality of New York—was determined to transform the city's industrial machinery and architectural scenes into symbols of people and their environment. Blending the clarity of Charles Sheeler's Precisionism with spatial and light dislocations more typical of de Chirico, Civitello uses muted, pastel colors to soften the hard-edged geometry inherent in his subjects. The absence of people lends a surreal note to his work that is consistent with Civitello's exploration of the world of subjective reality.

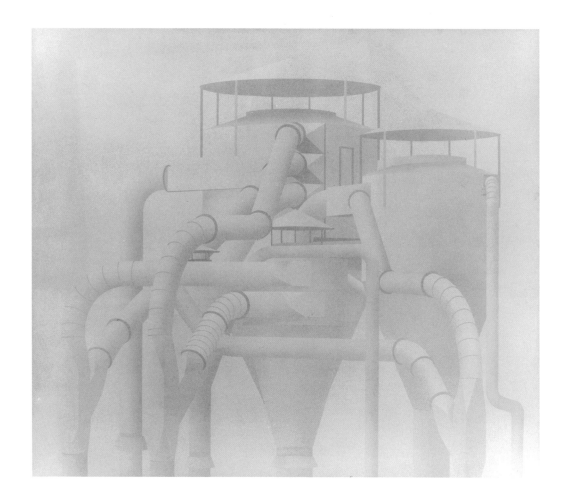

Barry Dalgleish
born Canada 1951

Interior with Still Life—New Year's Day
1981

oil and acrylic on canvas
65¾ x 48 (167 x 122)
provenance: Sibley Galleries, Nantucket, 1982

Dalgleish, who graduated in 1972 from the
Maryland Institute College of Art and received
an M.F.A. from Rochester Institute of Technol-
ogy, has taught for the past ten years at various
colleges and universities in upstate New York.
During the late 1970s he began a series of paint-
ings, based on studies of symmetry, in which he
creates strict formal compositions from recogniz-
able subjects, often small still lifes set into inte-
rior spaces. He reduces shapes to their geometric
fundamentals and controls pictorial elements
through carefully determined lighting effects.
Simple, generic titles dispel narrative associations
although subtitles frequently describe a mood or
specify time of day. Connections between
painted and actual space are achieved by the
realistically painted doorjambs and shutters that
often frame Dalgleish's canvases.

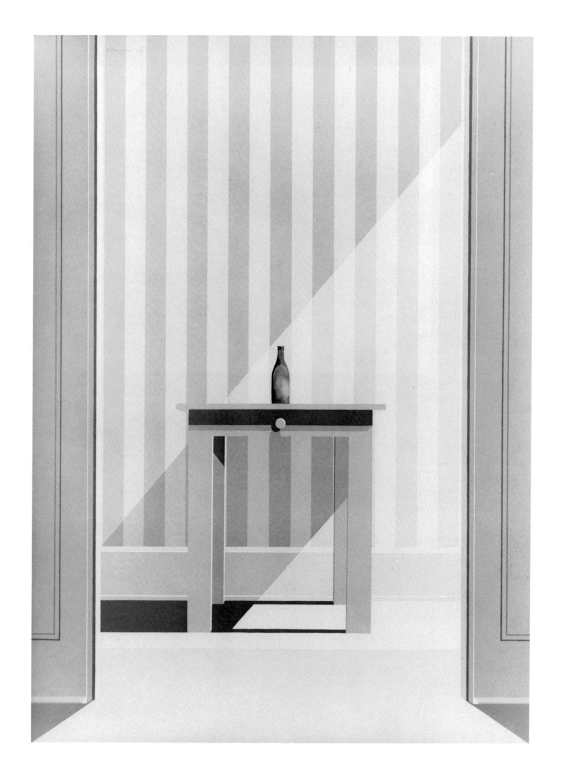

Stuart Davis
1894–1964

Memo
1956

oil on linen
36 x 28¼ (91.5 x 71.7)
provenance: The Downtown Gallery, New York,
1956

A student of Robert Henri and a childhood
friend of John Sloan, William Glackens, Everett
Shinn, and George Luks, Davis developed an
early affinity for the painterly style and urban
subjects of the Ash Can group. In 1913, the year
he began submitting drawings to *Harper's* and
The Masses, five of Davis's paintings were in-
cluded in the Armory Show, which he consid-
ered the "greatest single influence" he experi-
enced in his work. By 1915 or so, Davis was
experimenting with Cubist abstraction and col-
lage, and in his *Eggbeater* series of the late
1920s, which he later called the basis of every-
thing he subsequently painted, Davis analyzed a
simple still life in terms of Cubist geometry and
space. Although he employed a style that origi-
nated in Europe, Davis was an outspoken propo-
nent of America. He considered jazz "the only
thing that corresponded to an authentic art" in
the United States and introduced billboards, cig-
arette packages, jazz rhythms, and other symbols
of America into his paintings. Throughout his
life, but especially during the 1930s, Davis was a
social activist. He belonged to several left-wing
artists groups and eloquently defended abstrac-
tion as a viable vehicle for social comment.

José de Creeft
1884 Spain–1982 USA

Continuité
1958

marble
26 x 12½ x 11½ (66 x 31.7 x 29.2)
provenance: The Contemporaries, New York,
1959

De Creeft went to Paris in 1905 hoping to study
with Rodin, but the French sculptor sent him
instead to the Académie Julian. While a student
there, de Creeft took a studio at the "Bateau
Lavoir," the Montmartre building where Picasso
was at work on his famed *Demoiselles d'Avignon*.
Although he continued to model naturalistic fig-
ures akin to those of Rodin, de Creeft experi-
mented briefly with Cubism and assemblage.
Around 1915 he became committed to carving,
seeking to reveal the forms hidden within blocks
of stone or wood. Following his 1929 marriage
to a young American, de Creeft moved to New
York, although he continued to spend summers
in Europe until the mid 1930s. In the United
States de Creeft gained immediate recognition
and was invited to teach at Black Mountain Col-
lege and the Art Students League.

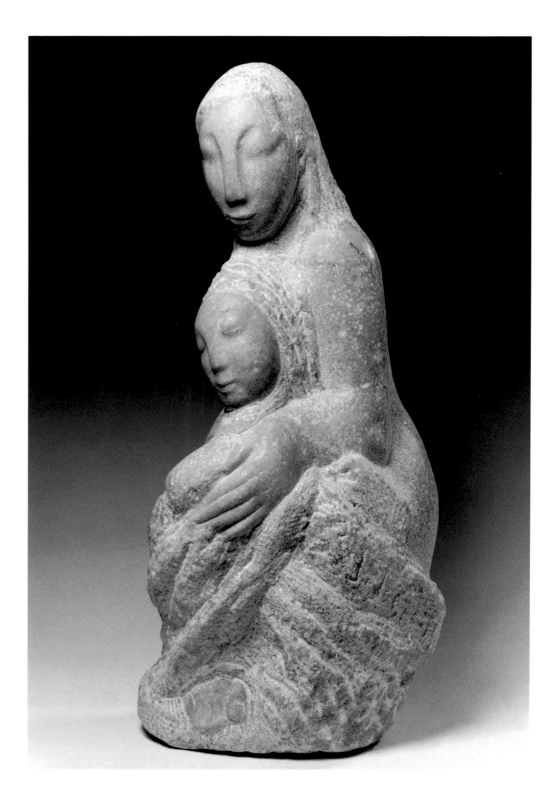

Roy De Forest
born 1930

The Real Inside Story
1973

acrylic on canvas
66 x 72⅛ (167.5 x 183.2)
provenance: Hanson Fuller Gallery, San
Francisco, 1974

De Forest calls art "one of the last strongholds of magic" and creates richly colored and textured fantasy worlds that he describes as "unknowable . . . [though] hauntingly familiar." De Forest studied at the California School of Fine Arts from 1950 to 1952 and received his B.A. and M.A. degrees from San Francisco State College. In the early 1960s he turned from the scrap metal constructions and canvases depicting mazes and abstract patterns that had been his primary interest during the 1950s to paintings in which animals, totemic images, and fantastical beings are the vehicles for storytelling and game playing. De Forest considers himself "an eccentric individual creating fantasy art with the amazing intention of totally building a miniature cosmos into which the artful alchemist could retire with all his friends, animals and paraphernalia."

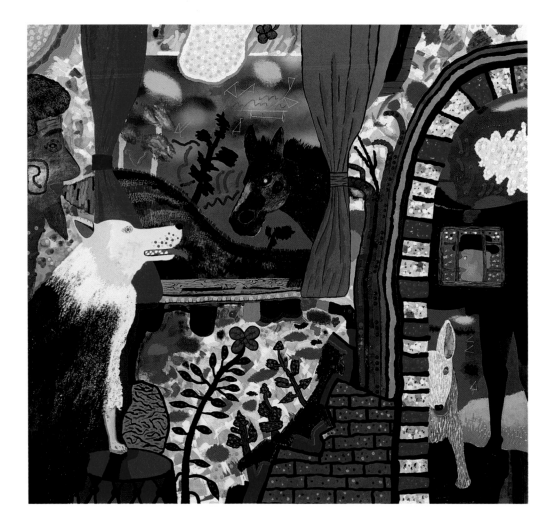

Richard de Menocal
born 1919

Calligraphy with Box and Glasses
1982

oil on canvas
17 x 28⅛ (43.2 x 71.4)
provenance: Main Street Gallery, Nantucket,
1982

De Menocal graduated from the school of the Boston Museum of Fine Arts. During his early career he drew illustrations for Condé Nast publications, organized displays for the Lord and Taylor department store in New York City, and created costume designs for Radio City Music Hall. He had his first solo exhibition in 1951, and continued to show in this country even after moving to Brazil. In the 1960s de Menocal withdrew from the secular world and spent over a decade at the Holy Apostles Seminary in Cromwell, Connecticut, and later with the Trappists in Derryville, Virginia, and Spencer, Massachusetts. After leaving the monastery he settled in Cambridge, Massachusetts, and returned to painting. In the still life arrangements for which he is best known, de Menocal is concerned with quietude of mood and with formal issues of balance and tone.

Simon Dinnerstein
born 1943

In Sleep
1983

conté crayon, colored pencil, and pastel on
paper mounted on paperboard
37¼ x 60 (94.2 x 152.4)
provenance: Staempfli Gallery, New York, 1984

Dinnerstein received a B.A. degree from The
City College of New York and studied on schol-
arship at the Brooklyn Museum Art School. He
received a Fulbright grant in 1970 and spent a
year in Kassel, Germany, the city where the
most advanced international art is brought to-
gether every four years for the famed Documenta
exhibitions. Dinnerstein left Germany, however,
with a high regard for the graphic precision of
German Renaissance art and a respect for tradi-
tion that was reconfirmed during his years in
Italy on a Prix de Rome. Dinnerstein, who
teaches at the New School for Social Research,
believes that art "should be accessible to the
laborer as well as the university professor." He is
primarily a painter of people, but literal tran-
scription of the observed world plays only a small
part in Dinnerstein's work; instead he paints a
world of imagination, often depicting dreams in
the skies above the real environments occupied
by his sitters.

Arthur G. Dove
1880–1946

Untitled (Landscape)
ca. 1938
ink and watercolor on paper mounted on
paperboard
5¹/₂ x 9¹/₁₆ (14 x 23.2)
provenance: Gift of William C. Dove, 1976

Untitled (Centerport)
1941
watercolor, gouache, ink and pencil on
paper mounted on paperboard
4¹/₁₆ x 5³/₈ (10.4 x 13.6)
provenance: Gift of William C. Dove, 1976

Arthur Dove, one of the pioneering abstract
painters of the early twentieth century, graduated
from Cornell in 1903 and worked for a period as
a magazine illustrator. His discovery, in Paris in
1908, of Matisse, the Fauves, and the Cubists,
as well as his encounter with aesthetic theories
that stressed spiritual expression, had a crucial
effect on his subsequent work. He spent much of
his year abroad in southern France with Alfred
Maurer, who provided Dove's introduction to his
lifelong friend and dealer, Alfred Stieglitz.
Throughout Dove's work, from the early "Nature
Symbolized" series, in which houses, sails, and
landscape elements are at times almost unrecog-
nizable, to his later abstractions, Dove translated
natural forms, sounds, and musical motifs into
powerfully expressive paintings. Although during
the 1920s Dove's sense of humor emerged in a
group of witty and formally inventive assem-
blages, his watercolors of the 1930s and 1940s,
in which he wove imagery "into a sequence of
formations" analogous to musical harmonies, are
among his most distinctive works.

Arthur G. Dove
Car Across the Street
1940
pen and ink and watercolor on paper
5⁹/₁₆ x 8⅞ (14.1 x 22.5)
provenance: Gift of William C. Dove, 1979

Black and White
1940
gouache on paper
5 x 7 (12.7 x 17.8)
provenance: Gift of William C. Dove, 1979

Jimmy Ernst
1920 Germany–1984 USA

Timescape
1956

oil on canvas
36 x 47⅞ (91.4 x 121.5)
provenance: Grace Borgenicht Gallery, New York, 1956

The son of Surrealist Max Ernst, Jimmy Ernst attended several European craft schools and served an apprenticeship in printing and typography before immigrating to the United States in 1938. He worked in advertising agencies and art galleries for several years, and not until age twenty did he decide to become a painter. Ernst's early canvases were tinged with Surrealism, and his first solo show featured organic abstractions. His interpretations of jazz themes during the 1940s, in which discrete color areas were used to approximate syncopation and rhythm, yielded in the 1950s to experiments with line that determined his future directions. In his mature work, Ernst used complex interlocking webs of line to manipulate pictorial space and to create architectonic structures. Always abstract, his later paintings possess the spatial quality of panoramic cityscapes.

Philip Evergood
1901–1973

Dowager in a Wheelchair
1952

oil on fiberboard
47⅞ x 36 (121.5 x 91.4)
provenance: A.C.A. Galleries, New York, 1958

Evergood was born in New York, but grew up in England and graduated from Eton in 1919. Two years later he entered the Slade School in London, but in 1923 he moved back to New York City and studied at the Art Students League with George Luks. For Evergood the 1930s were years of deep personal involvement in liberal and radical causes. He was president of the Artists Union and active in the American Artists' Congress, and in 1936 took part in the sit-down strike instituted by 219 artists protesting layoffs from the Federal Art Project. In the late 1930s, as managing supervisor of the New York WPA easel project, he fought aggressively to keep artists on the payroll when budget cuts forced layoffs. Evergood's art, like his other activities, reflects his devotion to egalitarian ideals, and his early paintings, especially, are statements of sympathy for those who struggle against oppression.

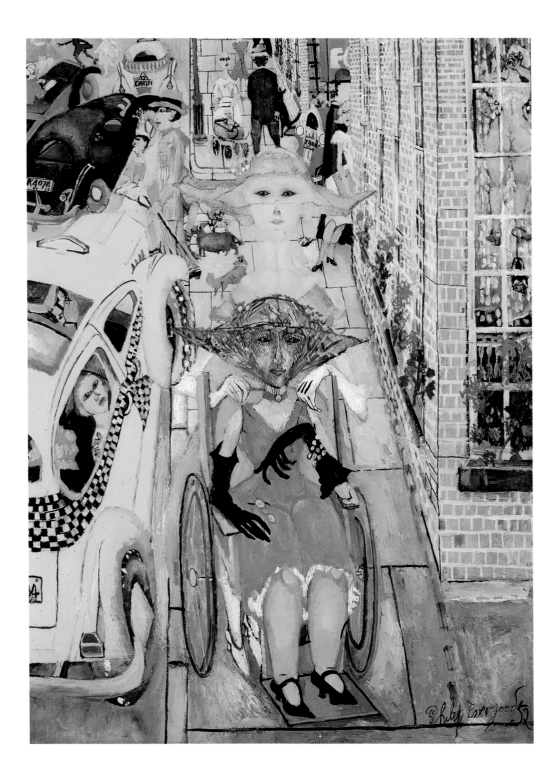

Alan Evan Feltus
born 1943

August 1983
1983

oil on linen
66⅛ x 44⅛ (168 x 112)
provenance: Forum Gallery, New York, 1983

Alan Feltus painted surrealistic compositions
while a student at Cooper Union in New York.
At Yale, where he completed his M.F.A. de-
gree, he found himself at stylistic odds with his
Abstract Expressionist teachers Lester Johnson
and Jack Tworkov. A 1970 Prix de Rome proved
the turning point in Feltus's career. Apart from
having time to work as he pleased, in Rome he
studied classical Greek sculpture and early Ren-
aissance art firsthand, and began figurative paint-
ings in which he sought the organization and
structural solidity he admired in Giotto, Piero
della Francesca, and Paolo Uccello. Feltus
paints the female figure in what appear to be
carefully posed arrangements, yet he is an intui-
tive artist who works without models or precon-
ceived compositional ideas. He seeks silence in
his work and avoids specific meanings, believing
that paintings "which are difficult or seemingly
impossible to fully comprehend" are most fasci-
nating.

Robert Ferris
born 1944

Rosie
ca. 1975

acrylic with dry brush on paper
36 x 45 (91.2 x 111.1)
provenance: Forum Gallery, New York, 1975

Following graduation from Yale, Ferris attended the Pratt School of Architecture and received an M.F.A. from Indiana University. His first show was held in 1966, and since that time he has had a number of solo exhibitions and has also participated in group shows throughout the United States. In 1977 Ferris exhibited highly detailed renderings of the Vermont woods where he lives. Yet, despite their photographic quality, Ferris's scenes are imaginary visions. Through viewpoint and scale he suggests that unseen actors play a part in the scenes he creates.

Sondra Freckelton
born 1936

Harvest
1978
watercolor and pencil on paper
44¹⁄₁₆ x 57⅝ (111.8 x 146.3)
provenance: Brooke Alexander, Inc., New York, 1979

Sondra Freckelton began making abstract sculptures in wood and plastic while a student at the Art Institute of Chicago. Although she met with resounding success as a sculptor, in the early 1970s she turned to realistic still lifes in watercolor. Freckelton now paints flowers, vegetables, and handmade objects associated with feminine family activities—quilts, garden implements, household objects that "are the quiet work of housewives and artisans." Her subjects speak "about life—about how we slept, ate and dreamed and lived." Recently Freckelton has exhibited oils and pastels for the first time and expanded her subject matter to include figures as well. She continues to celebrate the beauty of ordinary life in many of her canvases—one work, for example, shows a woman weeding a garden, another depicts Freckelton's husband, Jack Beal, tucked into bed with milk, cookies, and the *New York Times*.

Elias Friedensohn
1924–1991

Cain
1958

brush and ink on paper
18⁹⁄₁₆ x 25¼ (47.2 x 64.2)
provenance: Edwin Hewitt Gallery, New York,
1958

Although Friedensohn passed through several
stylistic phases during the thirty years after his
first mature works were shown in New York, he
never relinquished human themes as his primary
subject matter. In the late 1950s he cloaked
biblical and mythological motifs in abstract,
thickly impastoed surfaces appropriate to his
Abstract Expressionist bent. After a brief foray
into Pop imagery during the early 1960s,
Friedensohn renewed his appreciation for
classical form and combined sixteenth-century
Mannerist prototypes—Tintorettoesque flying
figures, for example—with such unlikely modern
paraphernalia as motorcycles in compositions
that attack the hypocrisy and hubris of the
modern era. A native New Yorker, Friedensohn
studied at the Tyler School of Art in Philadel-
phia, and privately in Paris with Gabriel Zendel,
before completing a B.A. degree at Queens
College, where he began teaching in 1959.

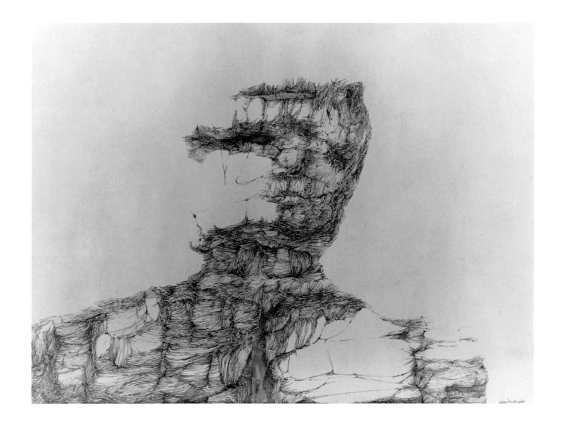

Suzi Gablik
born 1934

Tropism #12
1972

oil and photomechanical reproduction on canvas
24 x 24 (61.2 x 61.2)
provenance: Terry Dintenfass, Inc., New York,
1972

Gablik, who has lived in London for almost
twenty years, is a writer, critic, teacher, and
lecturer as well as a collage artist. She received a
B.A. from Hunter College, where she studied
with Robert Motherwell, and worked briefly at
Black Mountain College in the early 1950s.
Throughout her career as a visual artist she has
explored collage—pasting photographs cut from
magazines, garden catalogues, and other popular
media sources onto canvas and altering and unit-
ing the images with paint. Gablik, who is fasci-
nated with unusual connections, juxtaposes un-
likely elements in her work—an Indian Buddha
figure seated in a primeval swamp, for example,
is combined with a pair of crocodiles and a
tangle of snakes to create imaginary worlds that
are curious blends of primordial and science-
fiction fantasies.

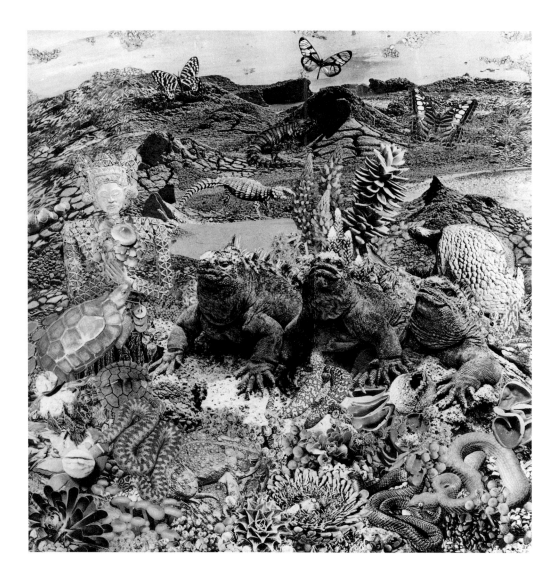

Frank Gallo
born 1933

Man in a Rocker
1965

cast and incised epoxy with burlap on wood base
38½ x 31 x 41⅜ (97.8 x 78.7 x 105.7)
provenance: Graham Gallery, New York, 1966

Gallo graduated from the University of Toledo and received his M.F.A. from the State University of Iowa. During the mid 1950s he studied further at Cranbrook Academy and worked with printmaker Mauricio Lasansky. A sculptor who teaches at the University of Illinois at Urbana, Gallo worked for many years in epoxy resin and received wide critical acclaim, especially for his figures of women, when his work was exhibited in the 1968 Venice Biennale. Although the media he uses would allow him to depict the physical qualities of his models to the tiniest detail, Gallo instead chooses hard, shiny surfaces that remain several times removed from the realism of his subjects. In a number of pieces, Gallo has further denied naturalism by creating shell-like figures whose flatness is emphasized by surface scratching. Gallo's enduring debt to Lasansky is apparent in the graphic surface quality of his earlier work as well as in his recent low reliefs.

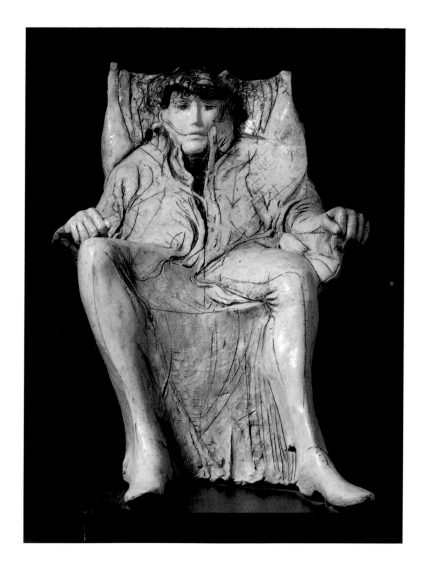

Gregory Gillespie
born 1936

Green Landscape
1971

oil, acrylic and paper collage on wood
9¾ x 12 (24.6 x 30.5)
provenance: Forum Gallery, New York, 1973

Following study at Cooper Union and the San
Francisco Art Institute, in 1962 Gillespie went to
Italy where he lived for the next eight years. The
small, visionary landscapes and fantasies he did
there incorporate elements of Flemish realism
with touches of Surrealism, Italianate religiosity,
and Germanic melancholia, and often depict fig-
ures engaged in disquieting confrontations. Gil-
lespie describes the work of these years as
"soaked with the textures of Italy—the feelings,
the colors." These works combine traditional
techniques (underpainting, glazing, and three-
point perspective) with overpainted or partially
scratched out collage elements in a way that
enhances the ambiguity of the imagery. On his
return to the United States in 1970 Gillespie
began working from life. His recent still lifes,
studies of landscape and vegetation, and self-
portraits are meticulously painted, yet they also
contain disturbing metaphysical presences that
are consonant with Gillespie's Italian phase.

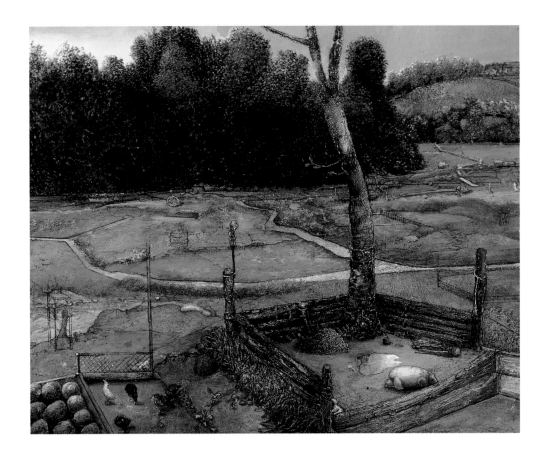

Rose Mary Gonnella-Butler
born 1957

Violet Interior with Lamp
1983

colored pencil and pencil on paper
16⁹⁄₁₆ x 24⅝ (42 x 62.4)
provenance: Sibley Galleries, Nantucket, 1983

Following undergraduate work at Rutgers University, Gonnella-Butler completed an M.F.A. degree in painting and drawing at Rochester Institute of Technology and studied computer graphics at the School of Visual Arts in New York. During the past several years she has served as instructor at Rutgers, Kean College, and the Newark Museum Studio School. Gonnella-Butler is fascinated with simple shapes and contrasting degrees of color opacity and employs imaginary color harmonies to evoke questions of time, impermanence, and change. She sets simple still-life arrangements and household objects into domestic scenes, and through altered scale, artificially arranged light, and manipulated space, her interiors take on the atmosphere of doll houses.

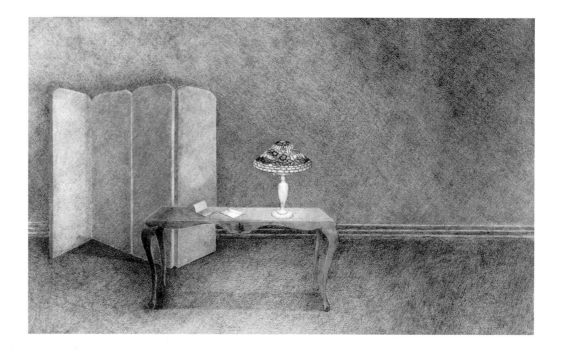

Sidney Goodman
born 1936

Elkins Park View

1971

charcoal and conté crayon on paper
27³⁄₁₆ x 41⁹⁄₁₆ (69 x 105.6)
provenance: Terry Dintenfass, Inc., New York,
1973

In 1954 Goodman entered the Philadelphia College of Art, where he studied illustration. A 1957 scholarship to the Yale-Norfolk summer school crystallized Goodman's decision to become a painter rather than an illustrator. In 1960, Goodman began teaching part-time at Philadelphia College of Art and remained there until the spring of 1979, when he joined the faculty of the Pennsylvania Academy. Goodman is a painter of landscapes and figures, and his early work had a strong metaphysical quality. From the mid 1960s until the late 1970s he was particularly concerned with what he calls " 'the violated landscape'—inanimate structures (water tanks, gas tanks, dumpsters, stadiums, incinerators, out of scale buildings) that threaten the harmony of nature." Goodman has recently completed a series of canvases on the elements in which he monumentalizes the powerful forces of earth, fire, water, and air.

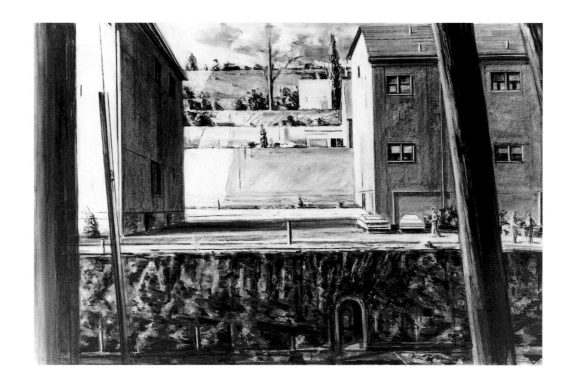

Morris Graves
born 1910

Hibernation

1954

watercolor on paper mounted on paper
18³⁄₁₆ x 26³⁄₈ (46.2 x 66.9)
provenance: Willard Gallery, New York, 1955

A protégé and close friend of Mark Tobey, Graves grew up in the Northwest and for many years made his home on an island in Puget Sound. Although he never received any formal artistic training (he didn't complete high school until age twenty-two), in 1932 he encountered Guy Anderson, a highly trained artist with whom he shared a studio. During the late 1930s Graves worked intermittently for the Federal Art Project and met Tobey, who became a friend and mentor and, along with experimental composer John Cage, helped nurture Graves's early interest in Oriental philosophy and religion. Protective of his solitude, Graves has lived mostly in remote rural areas, and uses the elements of nature as his subjects. Animals abound in his paintings and birds appear with special frequency, but towards a metaphorical rather than descriptive end. Shunning contact with contemporary industrial life, Graves in the 1960s painted abstractions based on the noises of the machine age with a degree of understanding possible only to one who cherishes quiet.

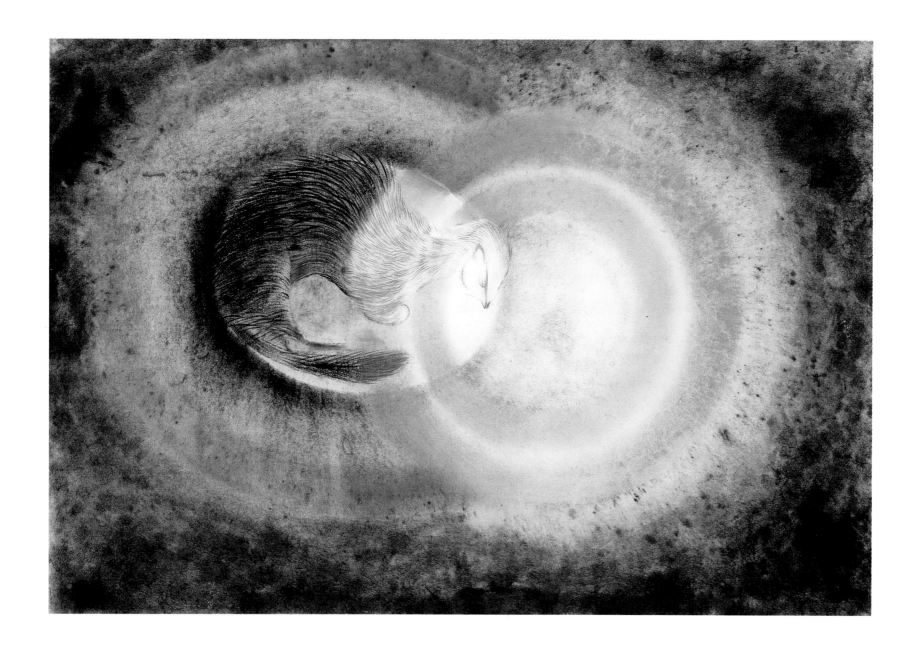

Nancy Grossman
born 1940

Twisting Column Figure
1976

coated paper, masking tape, analine dyes, water-
proof inks, and polymer glue on particle board
60⁹⁄₁₆ x 36¼ (153.2 x 92.1) (irregular)
provenance: Cordier & Ekstrom, Inc., New
York, 1976

Grossman completed a fine arts degree at Pratt
Institute in Brooklyn and subsequently received a
Guggenheim fellowship for travel abroad. Al-
though initially influenced by Richard Lindner
and David Smith, Grossman's paintings, col-
lages, and sculpture come out of a distinctly
individual understanding of the psychological
reality of contemporary life. Concerned with
people as victims, Grossman depicted headless
human forms tightly bound with shackles in a
series of drawings, and in collages created figures
whose contorted postures and featureless faces
convey an unidentifiable sense of panic. In the
late 1960s Grossman began her well-known
series of carved wooden heads. Covered with
leather, they often have closed zippers for
mouths and are adorned with horns, buttons, or
metal studs. In these sculptures Grossman sym-
bolizes repression and the bestial side of human
nature.

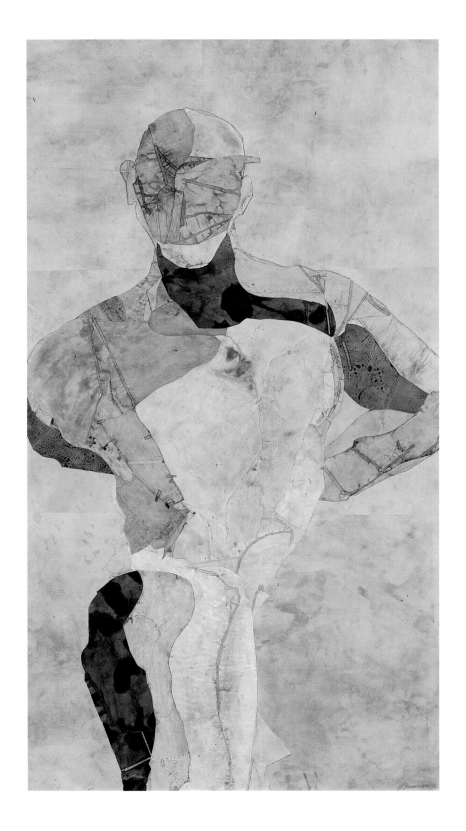

Nancy Grossman

Cob I
1980

carved wood, leather, nails, paint
17¾ x 9¼ x 10½ (45 x 23.5 x 26.8)
provenance: Barbara Gladstone Gallery,
New York, 1980

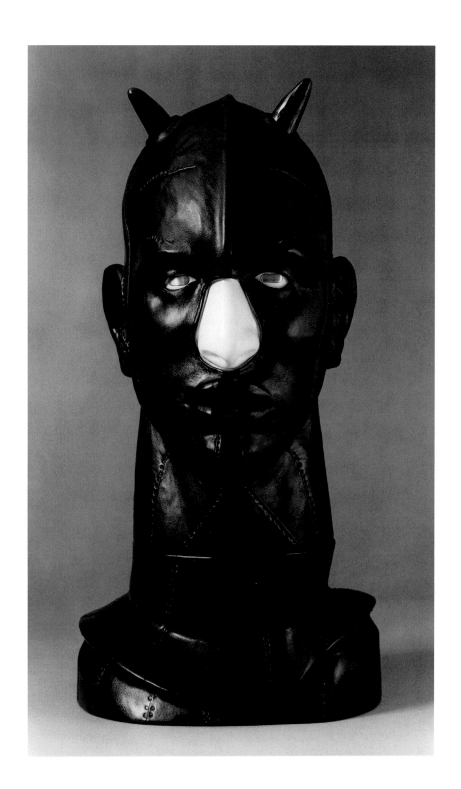

George Grosz
1893 Germany–1959 West Germany

A *Hunger Fantasy*
ca. 1947

watercolor and ink on paper
25 7⁄16 x 19 (64.5 x 48.3)
provenance: the artist, 1956

George Grosz studied art at the Kunstgewerbes-
chule in his native Berlin and at the Kunstakade-
mie in Dresden. He spent a summer in Paris,
but his enlistment in the German army during
World War I curtailed further work abroad.
Grosz's army experience proved psychologically
devastating. He was horrified at the immorality
and greed he saw, and in 1918 joined the Ger-
man Communist Party (KDP). Soon disillu-
sioned, he nevertheless remained a member of
the politically active German Dada movement.
Arrested several times by the German authorities
for publishing antigovernment and anticlerical
drawings during the 1920s, Grosz immediately
accepted an offer to teach at the Art Students
League in New York. In the United States in the
1930s, Grosz continued to employ the bitter sat-
ire of his Dada years, although his work took a
brief turn toward tranquility (before World War
II again threatened world stability). During the
1930s and 1940s, through the influence of Grosz
and Karl Zerbe, an important strain of American
Expressionism developed. Although he never re-
turned to live in his native Germany, Grosz was
elected to the Akademie der Kunst in Berlin in
1958 and died while visiting there the following
year.

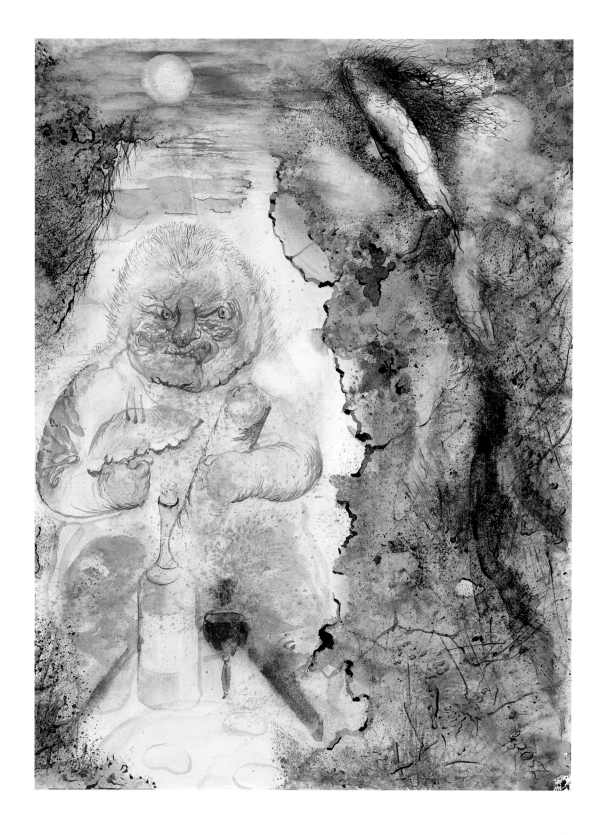

John André Gundelfinger
born France 1937

Dolly
n.d.

pencil on paper
10¾ x 8¹³⁄₁₆ (27.3 x 22.4)
provenance: John Bernard Myers Gallery,
New York, 1973

Gundelfinger immigrated to the United States at
age two. He studied at the School of Visual Arts
in New York City and at New York University,
and in 1963 he returned to the School of Visual
Arts as an instructor of painting and drawing.
Since 1971 he has also taught at the Parsons
School of Design. Known primarily as a painter
of misty landscapes—the Delaware water gap is a
favorite site—Gundelfinger is less concerned
with the geography of his scenes than with
mood, atmosphere, and the changing perception
of time created by subtly altering light and color.
An admitted heir of both J. M. W. Turner and
Willem de Kooning, Gundelfinger is fascinated
with the implicit position of the viewer within
the landscape and with the changing relation-
ships among landscape elements afforded by very
small adjustments of viewpoint. At the core of
his art is the re-creation of experience: from
visible and objective to invisible and subjective.

Howard Edwin Hack
born 1932

Window Number 22, Parenti's Market
1967

oil on canvas
63⅞ x 59¾ (162.3 x 151.8)
provenance: Gump's, San Francisco, 1968

At age eighteen Hack moved to San Francisco where he became closely allied with the Bay Area Figuration movement of the 1950s and 1960s. A summer student of Yasuo Kuniyoshi at Mills College, Hack also studied intermittently at the California College of Arts and Crafts in the late 1940s and 1950s, and in 1962 earned a B.S. in philosophy from the University of San Francisco. During the early 1960s Hack painted the simplified shapes of pavement markings and manhole lids using a heavily impastoed technique. In the mid 1960s he began portraying the old office windows and storefronts along picturesque Mission Street near his studio in a series that provides an early link between Bay Area Figuration and Photorealism, its late-1960s offshoot. In the smoothly painted window series Hack explored opacity and translucence of light and color and the dichotomy of real versus reflected imagery. More recently he has worked with graphic media, including silverpoint drawings and blueprints.

Nathan Cabot Hale
born 1925

Wheel of Life
1968

cast and welded nickel silver on wood base
24 x 13¼ x 9¼ (61 x 33.7 x 23.5)
provenance: Midtown Galleries, New York, 1969

Hale was educated at Chouinard Art Institute in Los Angeles and the Art Students League during the 1940s. He returned to formal studies in the 1970s and received a Ph.D. in morphology and perceptual psychology from Union Graduate School. Since the 1950s he has lectured extensively at a variety of institutions, and currently teaches anatomy and the elements of drawing at the Art Students League in New York. A widely traveled man, Hale's interests range from the development of sophisticated metalworking techniques for sculpture to more broadly based humanistic concerns. Through his sculpture and writings Hale explores the cycle of life and the growth and forming processes of humankind, concerns that led him to establish The Ages of Man Foundation, an organization in Amenia, New York, dedicated to creating a sculpture park and chapel based on the cycle of life theme.

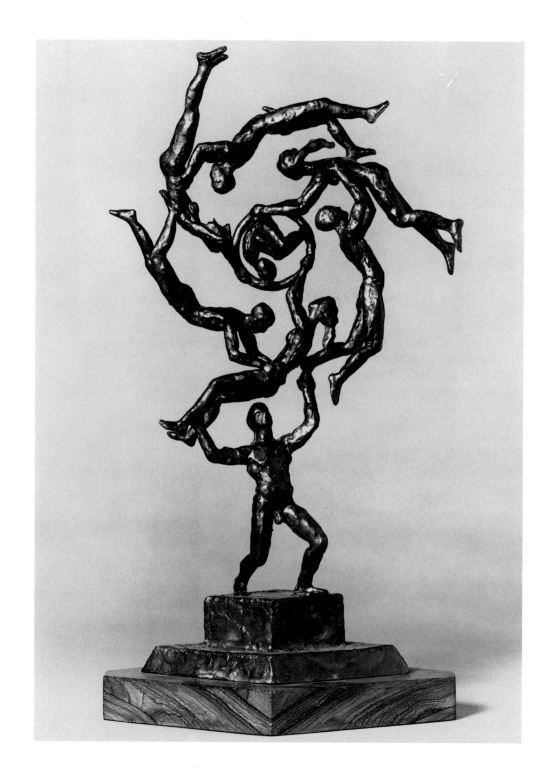

John Edward Heliker
born 1909

The Howard House
1965

oil on canvas
50¼ x 52 (127.6 x 132.1)
provenance: Kraushaar Galleries, New York,
1965

Determined to become an artist, Heliker dropped
out of high school to copy paintings at the Met-
ropolitan Museum. From 1927 until 1929 he
studied with Kimon Nicolaides, Thomas Hart
Benton, and Boardman Robinson at the Art Stu-
dents League. After several years away Heliker
returned to New York in the 1930s and in 1947
joined the faculty at Columbia University where
he taught until his retirement. Heliker won a
Prix de Rome in 1948 and spent the next five
summers in Italy. At this time larger strokes and
freer designs began replacing the structural, Cé-
zannesque abstractions that occupied him in the
1940s and early 1950s. A painter of landscapes,
portraits, and still lifes, Heliker chooses tradi-
tional subject matter for his semi-abstract, paint-
erly compositions.

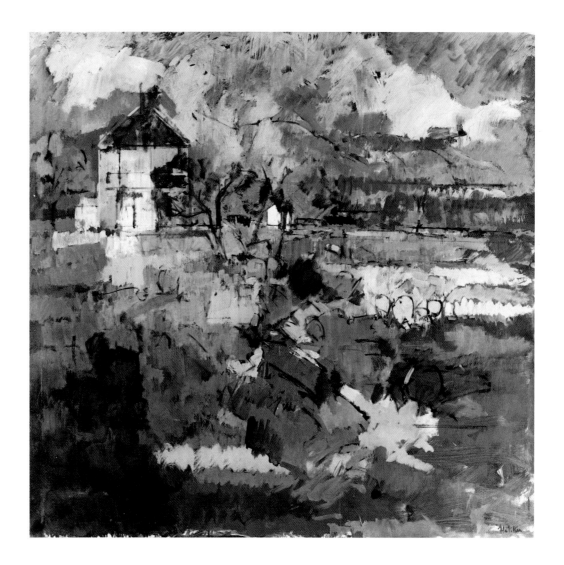

73

Edward Hopper
1882–1967

White River at Sharon

1937

watercolor and pencil on paper
21¾ x 29¾ (55.3 x 75.6) (irregular)
provenance: Frank K. M. Rehn, Inc., New
York, 1955

A quintessential American realist, Hopper
painted a repertoire of subjects ranging from the
lighthouses and Victorian manses of the New
England coast to the movie houses, offices, cafe-
terias, and highways of New York City. Hopper
was associated with the Ash Can artists early in
his career; he studied with Robert Henri at the
New York School of Art from 1900 to 1906 and
greatly admired John Sloan's etchings of New
York City. In the 1920s he achieved recognition
with his architectural paintings in which light is
used dramatically to characterize his subjects.
Whether depicting daylight scenes or nocturnal
environments, his paintings have an introspec-
tive, contemplative aura that is enhanced by his
frequent use of solitary figures set against blank
walls. Mood was as important to Hopper as sub-
ject, as the statement he wrote for the catalogue
of his 1933 retrospective at the Museum of Mod-
ern Art makes clear: "My aim in painting has
always been the most exact transcription possible
of my most intimate impressions of nature."

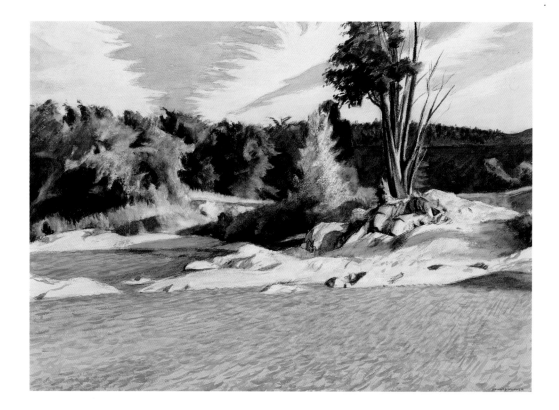

Edward Hopper
Cape Cod Morning
1950

oil on canvas
34¼ x 40⅛ (86.7 x 102)
provenance: Frank K. M. Rehn, Inc., New
York, 1955

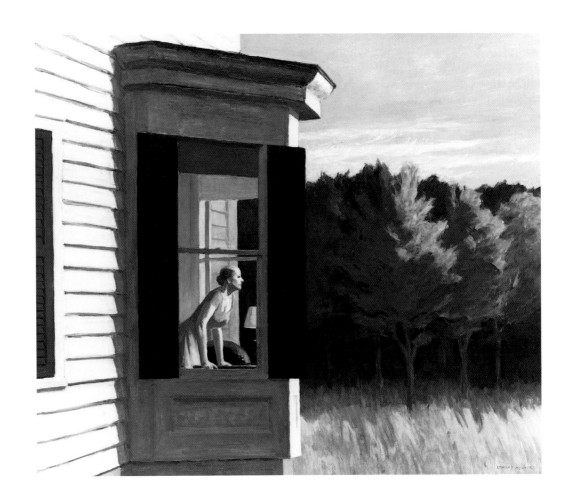

Wolf Kahn
born Germany 1927

High Summer
1972

oil on canvas
50 x 58¾ (126.9 x 149)
provenance: Grace Borgenicht Gallery, New
York, 1972

Kahn, who immigrated to the United States at
age thirteen, studied with Stuart Davis (at the
New School for Social Research) and with Hans
Hofmann, and in 1951 he completed a B.A. at
the University of Chicago. Back in New York in
1952, Kahn and several other Hofmann students
organized the Hansa Gallery, a cooperative
named for their teacher. Avoiding a specific aes-
thetic program, the Hansa artists, who numbered
ten to fifteen members at a time, tended toward
either painterly realism with expressionist over-
tones (Kahn and Alan Kaprow) or found-object
constructivism (Richard Stankiewicz and John
Chamberlain). In the 1960s the bright colors and
energetic brushwork characteristic of Kahn's
Hansa years gave way to muted tones, simplified
compositions, and quiet paint handling. Kahn
sees his landscapes as meditations on the world
in which color relates light with subject, and in
which horizons, nature's dividing lines, are
seamless fusions between sky and land. The re-
cipient of Fulbright and Guggenheim grants,
Kahn has taught at the University of California
at Berkeley, at the Cooper Union Art School,
and at Dartmouth College.

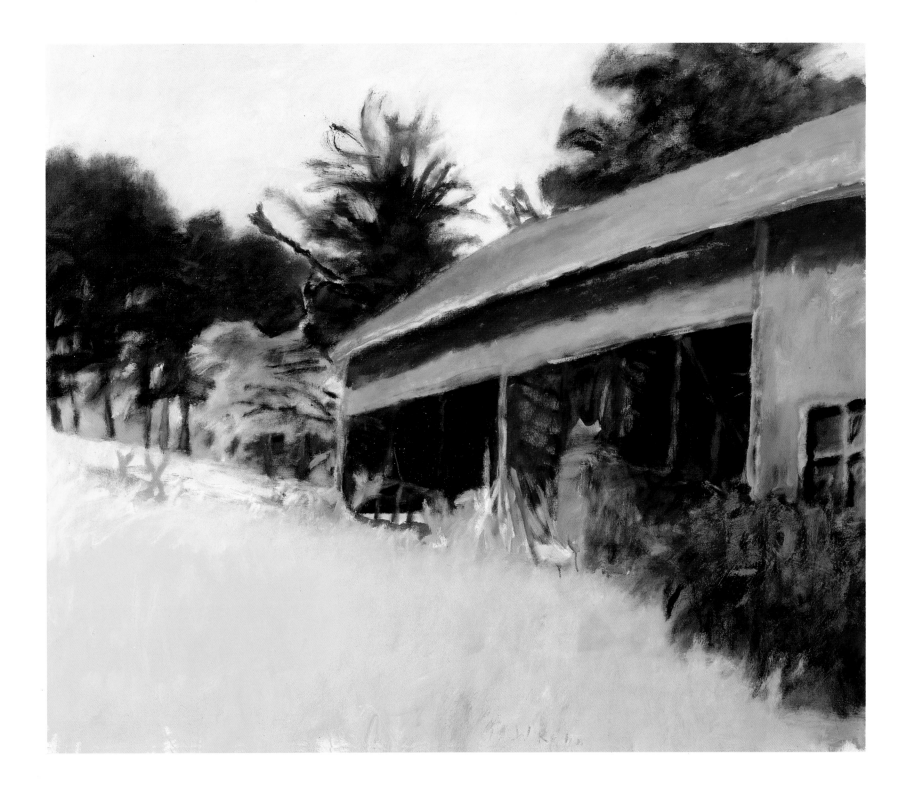

Ben Kamihira
born 1925

Tree in the Square
1970

oil on linen
38⅛ x 51⅛ (96.9 x 129.9)
provenance: Forum Gallery, New York, 1971

Following internment with his Japanese-born parents at the beginning of World War II, Kamihira was drafted into the U.S. Army. On the GI Bill he attended the Art Institute of Pittsburgh and the Pennsylvania Academy of the Fine Arts where he studied with Walter Stuempfig and Francis Speight. Kamihira has taught at the Pennsylvania Academy and Pennsylvania State University, and he served as artist-in-residence at Rice University in Houston. His aesthetic roots can be traced to the Venetian masters of the sixteenth and seventeenth centuries—Veronese, Tintoretto, Guardi—and his early landscapes, figural subjects, and religious themes reflect his interest in Baroque compositional devices. Yet Kamihira is also indebted to recent movements. His abiding interest in dramatic lighting and surface textures—he executes satins and brocades with exquisite attention to tactile effects—and his use of illogical viewpoints and spatial arrangements suggest links with European Surrealism of the 1930s.

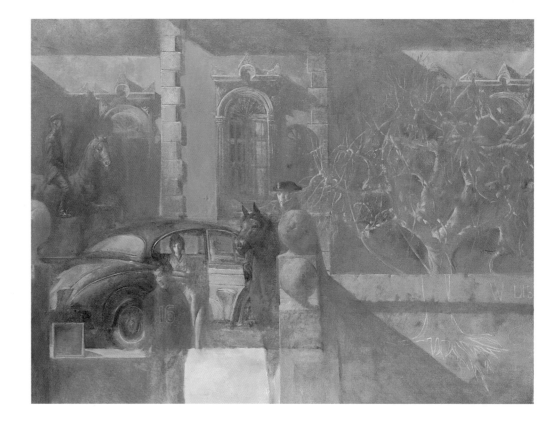

Herbert Katzman

born 1923

Self Portrait
1967

sepia chalk on paper
56⅛ x 42⅛ (142.5 x 107)
provenance: Terry Dintenfass, Inc., New York,
1971

Following high school, Katzman enrolled at the
Art Institute of Chicago, but with the onset of
World War II, he postponed his studies and
joined the navy. After receiving a medical dis-
charge, he returned to Chicago to work with
Boris Anisfeld, who introduced him to German
and French Expressionism. In 1947, funded by a
travel grant, Katzman set off for Paris to study
the great Expressionists firsthand. On his return
to New York, where he currently teaches at the
School of Visual Arts, Katzman showed urban
landscapes and figure paintings that met with
immediate success. Visually rather than intellec-
tually responsive to his subjects, Katzman has
recently completed a group of homage paintings
that reflect his ongoing commitment to Expres-
sionist masters Chaim Soutine, Edvard Munch,
Oskar Kokoschka, and Marsden Hartley.

James Joseph Kearns
born 1924

Children's Games
1959
oil on fiberboard
36 x 48⅛ (91.4 x 122.3)
provenance: G Gallery, New York, 1960

Kearns views his primary subject matter, the human figure, as an embodiment of the human spirit. A sculptor who works in fiberglass, and a painter as well, Kearns seeks to portray "Man as Total Man—the Tragic, Complex and Joyful Man." Kearns received a B.F.A. in 1950 from the Art Institute of Chicago and held a factory job for ten years to support his family. He has devoted a major portion of his time to teaching; since 1959 he has been an instructor at the School of Visual Arts in New York and has also taught at Fairleigh Dickinson University in New Jersey and at the Skowhegan School of Art in Maine.

Leon Kelly
1901 France–1982 USA

Cascade of Souls to Earth
1958

pen and ink on paper
24¹³⁄₁₆ x 19 (62.9 x 48.3)
provenance: Alexander Iolas Gallery, New York,
1959

Kelly enrolled in the School of Industrial Art
(now the Philadelphia College of Art) in 1921
and later studied with Arthur B. Carles and
Earle Horter at the Pennsylvania Academy.
Horter's interest in Cubism and his private col-
lection of paintings and books strongly influ-
enced Kelly's early work, which resembled ana-
lytic Cubism. During six years in Paris,
however, Kelly elected to copy old masters at the
Louvre rather than to seek out the city's avant-
garde artists. By the early 1940s he was experi-
menting with Surrealism, creating macabre can-
vases depicting enormous insects and abstract
forms resembling flayed human musculature. In
his later years Kelly returned to figurative art,
declaring that "we must resolve everything . . .
in the form of our own being."

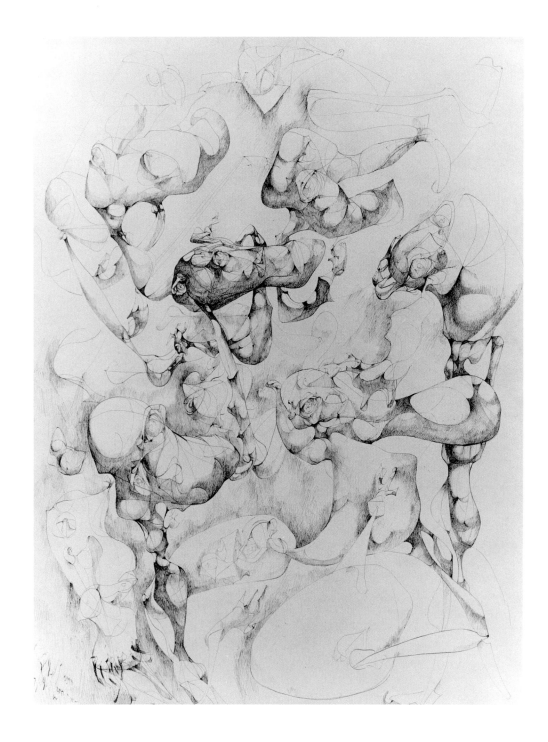

William Kienbusch
1914–1980

Across Four Pines (Hurricane Island)
1956

casein on paper mounted on paperboard
40⅝ x 26⅞ (103.2 x 68.3)
provenance: Kraushaar Galleries, New York,
1956

A magna cum laude graduate of Princeton,
Kienbusch studied at the Art Students League,
the Colorado Springs Fine Arts Center, the
Academy Colarossi, and with Abraham Rattner
in Paris. Despite additional work with Anton
Refregier and Stuart Davis, Kienbusch did not
find his true identity as an artist until he spent
the summers of 1940 and 1941 in Stonington,
Maine. There he discovered the powerful Maine
landscape that had attracted Winslow Homer,
John Marin, and Marsden Hartley. Hartley's
work, especially, provided a stylistic model, and
his desire to express the "inner reality of the
world of nature" coincided with Kienbusch's
own feelings. Best known for semi-abstract land-
scapes, Kienbusch spent summers photographing
and sketching the pine trees, buoys, and shacks
of the Maine coast, and during the winter
months, while teaching at the Brooklyn Museum
School, translated his summer's work into geo-
metrically formulated landscapes. During the
1960s Kienbusch adopted a looser technique to
capture better the dynamic rhythms of natural
forces.

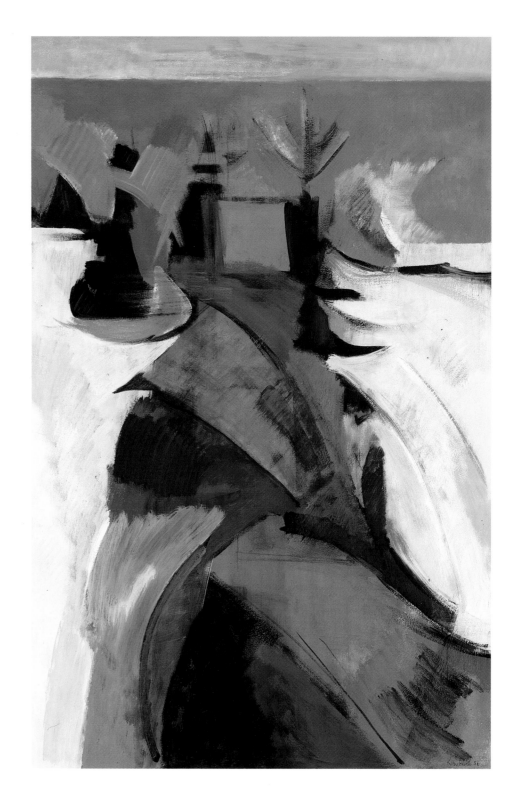

William King
born 1925

Yes and No
1979
stained and painted wood
43¼ x 13¾ x 22⅝ (109.9 x 34.9 x 57.5)
provenance: Terry Dintenfass, Inc., New York, 1980

A native of Jacksonville, King studied engineering at the University of Florida before entering the Cooper Union Art School. Additional studies at the Accademia dei Belli Arte in Rome, made possible by a Fulbright grant, and at the Central School in London in 1952 completed King's formal artistic training. Since then King has taught intermittently at the Brooklyn Museum School, the University of California at Berkeley, the Art Students League, the University of Pennsylvania, and various branches of the State University of New York. A sculptor who works in materials as diverse as vinyl and bronze, King uses long-legged, lanky male figures to explore human foible and pose. Body type and scale provide a never-ending source of formal and thematic richness, and through witty choreography, King's figures leer, ponder, share, love, and otherwise exemplify the emotions, drama, and humor of everyday life.

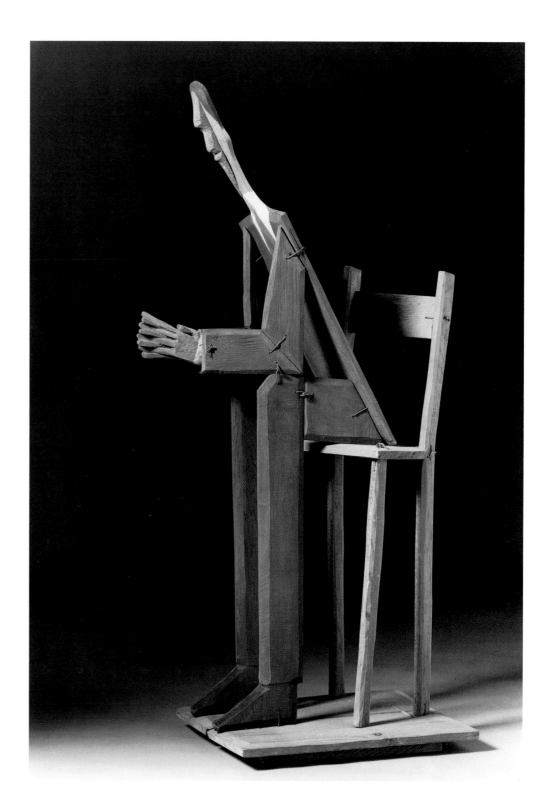

William King
Any Questions?
1985

vinyl on metal frame
91½ x 52½ x 21⅛ (232.2 x 133.4 x 53.6)
provenance: Terry Dintenfass, Inc., New York,
1985

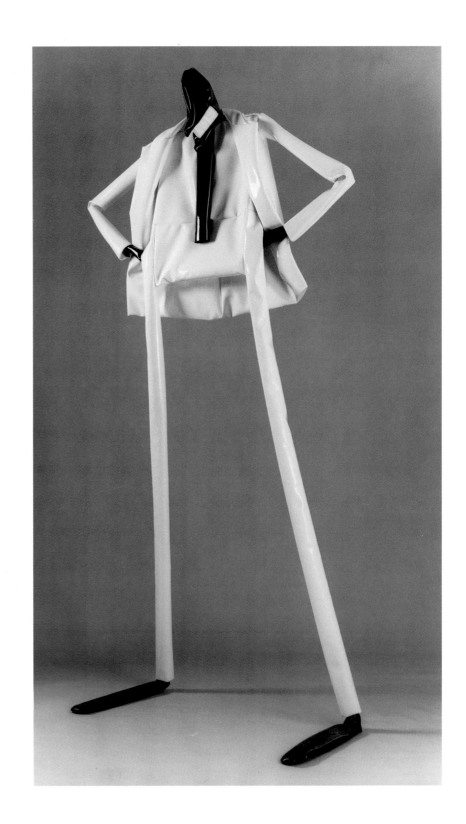

Karl Knaths
1891–1971

Clam Diggers
1959

oil on canvas
42⅛ x 60 (107 x 152.4)
provenance: Paul Rosenberg & Co., New York,
1960

Although Knaths saw the Armory Show in Chicago while a student at the School of the Art Institute, it was not until he moved to Provincetown in 1919 (where he lived the remainder of his life) that he began to incorporate Cubist notions of form and space into his paintings. Knaths, who once explained that "I break things up for their plastic qualities, but I don't deform them," never abandoned subject matter despite his Cubist-inspired format, and many of his subjects—decoys, beach scenes, clam diggers, still lifes—were drawn from the environment around Provincetown. Throughout his life he returned to favorite themes, and in his later work he was increasingly attracted to abstracted forms. In the 1930s Knaths worked on the Massachusetts WPA project, but at other times supported himself through carpentry work and occasional teaching jobs. For many years Duncan Phillips was Knath's only patron, and between 1937 and 1950 Knaths taught an annual six-week course at the Phillips Gallery school in Washington, D.C.

Yasuo Kuniyoshi
1893 Japan–1953 USA

Strong Woman and Child
1925

oil on canvas mounted on linen
57⅜ x 44⅞ (145.4 x 114)
provenance: Mr. and Mrs. Harold Goldsmith,
The Downtown Gallery, New York, 1956

After immigrating to the United States in 1906,
Kuniyoshi lived briefly in Seattle, then moved to
Los Angeles and subsequently to New York
where he studied at the Robert Henri School,
the Independent School, and at the Art Students
League. Hamilton Easter Field, patron and
friend of Robert Laurent, befriended Kuniyoshi
and provided a studio in Maine in 1918 and
1919. Kuniyoshi supported himself as a photog-
rapher during the twenties and joined the WPA
print division in the 1930s. He was active in the
American Artists Congress until internal divi-
sions split the group in 1940. A social realist
during much of his career, Kuniyoshi has ranged
stylistically from experiments with hard-edged
volumetric form and distorted space to fluid
strokes and soft edges akin to the work of his
friend Jules Pascin. During the last five years of
his life, especially, Kuniyoshi's sympathetic so-
cial realist themes gave way to brilliant color and
once again to geometric designs.

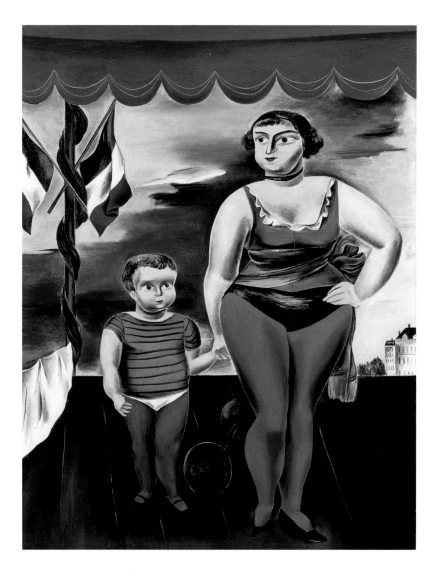

Yasuo Kuniyoshi
Fakirs
1951

oil on canvas
50¼ x 23¼ (127.7 x 82)
provenance: The Downtown Gallery, New York,
1956

Bruce Kurland
born 1938

Bone, Cup and Crab Apple
1972

oil on fiberboard
8⅛ x 10 (20.6 x 25.4)
provenance: Washburn Gallery, New York, 1973

A student at the National Academy and the Art Students League in the early 1960s, Bruce Kurland paints tiny still lifes of birds, flowers, fruit, game, and contemporary debris (Budweiser beer cans, Coca Cola bottles). The consummate realism of his earlier work reflects his simultaneous fascination with Chardin, seventeenth-century Dutch still-life master Karel Fabritius, and contemporary formal issues of balance and rhythm. Since 1977 Kurland has introduced fantasy forms into his work and exchanged carefully controlled lighting effects for diffuse, surreal, often shadowless spaces. Always precariously balanced, his objects now defy gravitational laws; outlines refuse to be contained, and the descriptive realism of the earlier work has been supplanted by an overriding concern for mood.

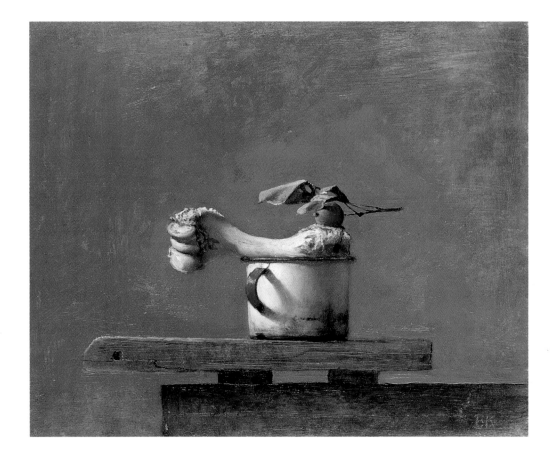

Gaston Lachaise
1882 France–1935 USA

Head of a Woman
1923 (cast 1935)

bronze on marble base
15¼ x 8½ x 10 (38.7 x 21.6 x 25.3)
provenance: The Downtown Gallery, New York,
1959

Lachaise studied at the Ecole Bernard Palissy
and the Académie Nationale des Beaux-Arts in
his native Paris. A year's employment with René
Lalique provided passage money, and in 1906,
with thirty dollars in his pocket and no knowl-
edge of English, he traveled to Boston in pursuit
of the woman who would later become his wife
and frequent model. After six years of work on
Civil War memorial statues with Henry Hudson
Kitson, he became Paul Manship's assistant in
New York. His real breakthrough came when he
met Arthur B. Davies, who invited Lachaise's
participation in the 1913 Armory Show. In New
York, Lachaise was soon involved in progressive
art circles. As president of the Society of Inde-
pendent Artists, he worked with Walter Pach,
John Sloan, Gertrude Vanderbilt Whitney, Rob-
ert Henri, and other influential artists. Although
during the early 1920s Lachaise frequently
sculpted animal and bird themes, he is best
known for his portraits and for his sensuous, full-
figured women. He executed commissions for
the American Telephone and Telegraph and
RCA buildings in New York, and created the
National Coast Guard Memorial in Washington,
D.C.

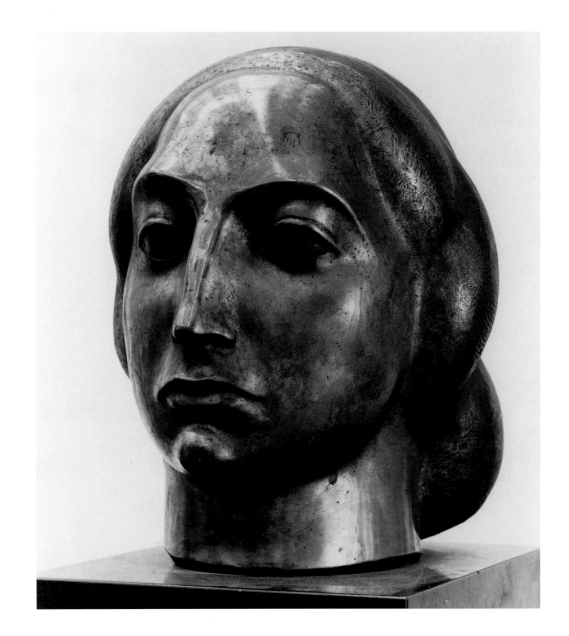

Edward Laning
1906–1981

The Good Companions
1960

oil on fiberboard
12 x 9 (30.5 x 22.8)
provenance: the artist, 1973

A native of Illinois, Edward Laning matured as
an artist during the heyday of Regionalism and
American Scene painting. Laning, whose grand-
fathers were both in populist politics, enjoyed a
longtime friendship with Edgar Lee Masters, so
it is no surprise that after an initial brush with
modernism, he became a traditionalist with a
bent for social satire. Studies in the late 1920s
with Kenneth Hayes Miller, Reginald Marsh,
and John Sloan at the Art Students League
(where Laning himself taught from 1952 until
1975) confirmed this predilection. But it was
Rubens's *Descent from the Cross* that inspired
Laning's commitment to mural painting. During
the 1930s, Laning's WPA commission to depict
the role of immigrants in American industrial
life for the immigration center at Ellis Island,
along with his New York Public Library murals,
brought him both renown and experience. Al-
though Laning's easel paintings of the 1930s and
1940s, like the work of his friends Isabel Bishop
and Reginald Marsh, reflected his concern for
social issues by depicting the working-class peo-
ple around Union Square, his later paintings
have a dreamlike quality not found in the earlier
work.

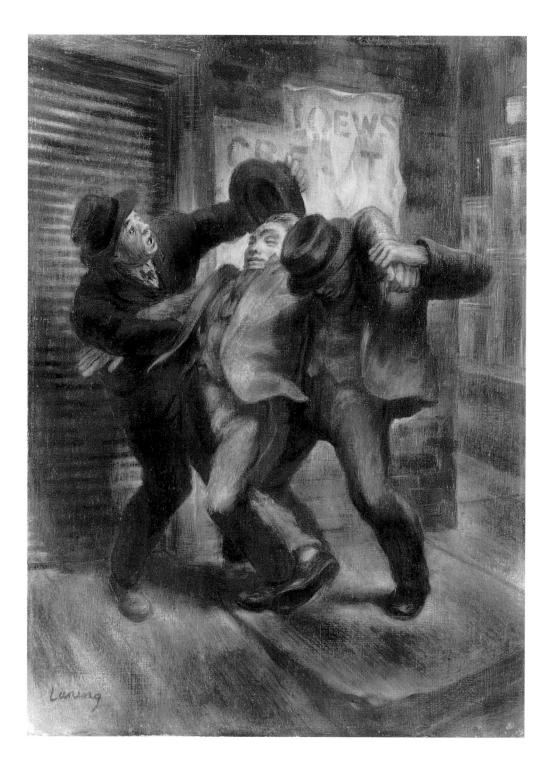

Jacob Lawrence
born 1917

Dreams No. 2
1965

tempera on fiberboard
35¾ x 24 (90.8 x 61)
provenance: Terry Dintenfass, Inc., New York, 1966

Lawrence first studied art as a child at a New York settlement house where his work attracted the attention of Charles Alston. In 1937 Lawrence joined a Civilian Conservation Corps work gang, but a scholarship to the American Artists School brought him back to painting and in 1939 he was hired by the WPA. Lawrence's predilection for narrative biography emerged in his 1938 series on the life of Haitian patriot and martyr Toussaint L'Ouverture, and in cycles tracing the lives of Harriet Tubman and John Brown. Lawrence's first major exhibition, which opened the day Pearl Harbor was bombed, featured his series of paintings on the migration of Negroes after World War I, twenty-six of which were reproduced in *Fortune* magazine. The exhibition made Lawrence an overnight success. The prejudice Lawrence experienced while serving as a Coast Guard steward's mate during the war resulted in the only bitter, satiric drawings of his career. Although Lawrence claims influence from Brueghel, Goya, Daumier, and the Mexican muralists, the lineage is thematic rather than stylistic. He reduces figures to simple shapes, often silhouettes, and alters scale for pictorial effect, creating a posterlike quality which he emphasizes through the matte surfaces of gouache and casein.

David Levine
born 1926

Senator Dirksen
1968

pen and ink on paper
11¹⁄₁₆ x 6¹¹⁄₁₆ (28.1 x 17)
provenance: Forum Gallery, New York, 1970

Levine originally intended to be a comic-book artist, but his parents sent him to Tyler School of Art to pursue a career as a painter. The scenes of garment workers—plying their trade and enjoying moments of relaxation—that Levine presented in his first solo show in New York in 1953 reflected a concern for social issues that persists in his paintings as well as in his caricatures. In the late 1950s *Esquire*'s Clay Felker saw some of Levine's caricatures, and soon he was drawing for *Esquire, The New York Review of Books,* and other prominent magazines. Despite his international fame as a caricaturist, however, Levine considers himself "a painter supported by … satirical drawings" and a traditionalist who has learned a great deal from Rembrandt. Basing much of his work on nineteenth-century models, Levine nevertheless captures the immediacy of the stop-action moment in his portraits, beach scenes, and figure studies.

Jack Levine
born 1915

Inauguration
1956–58

oil on canvas
72 x 63 (183 x 160)
provenance: The Alan Gallery, New York, 1958

The youngest of eight children, Jack Levine was
born in south Boston of Jewish immigrant par-
ents. Along with Hyman Bloom, he studied with
Harold Zimmerman and Denman Ross while
still a teenager, and his early work reflects their
emphasis on Old Master traditions. In 1935,
shortly after its formation, Levine joined the
WPA's Federal Art Project, where he was em-
ployed intermittently until 1939. In 1937, while
with the WPA, Levine painted *The Feast of Pure
Reason*, the work that catapulted him to fame.
The painting, which depicted a politician, a po-
liceman, and a "gentleman" of wealth, was in-
terpreted by the press as an indictment of police
corruption and its connection to wealth and or-
ganized crime. Levine is noted as a social realist
and draws his subjects—sometimes scenes sym-
pathetic to the socially oppressed and sometimes
satiric commentaries on social and political situ-
ations—from contemporary life. Like Bloom, he
is an Expressionist whose painterly style is rooted
in early twentieth-century German art.

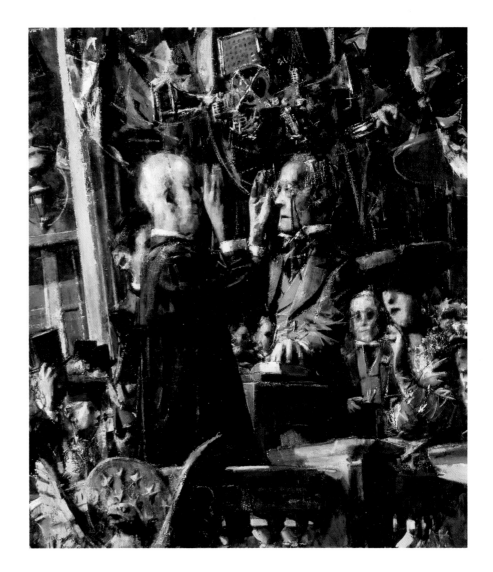

David Ligare
born 1945

Sand Drawing #3
1971

pencil on paper
19⁵⁄₁₆ x 16⁹⁄₁₆ (49.1 x 42)
provenance: A.C.A. Galleries, New York, 1971

A painter in oil and watercolor as well as a draughtsman, David Ligare received his art training at the Chouinard Art Institute and at the Art Center College of Design in Los Angeles. Ligare selects isolated aspects of the landscape to express universal concepts. The drawings featured in his first solo show in New York were transpositions onto paper of blurred footprints and abstract patterns drawn originally in sand. Resembling two-dimensional earthworks they reflect Ligare's affinity for environmental and process art. Space and time continue to concern Ligare, and in recent paintings of Greek landscapes and architectural fragments, strict compositional arrangements create a dialectic between reality and timelessness.

Louis Lozowick
1892 Russia–1973 USA

Bridge
1960

pen and ink, ink wash, and pencil on paper
24⁹⁄₁₆ x 20 (62.3 x 50.8)
provenance: Zabriskie Gallery, New York, 1973

Lozowick attended art school in Kiev for two years. In 1906 he moved to New York with his family, and in 1912 he entered the school of the National Academy of Design where he studied with Leon Kroll and Emil Carlsen. He subsequently graduated Phi Beta Kappa from Ohio State University and joined the army in 1918. In Berlin in 1920 he became friends with Laszlo Moholy-Nagy, El Lissitsky, and the avant-garde Russian artists affiliated with the November-gruppe. On his return to New York in 1924 he joined the executive board of the *New Masses* and exhibited his machine drawings in the 1926 exhibition of Katherine Dreier's Société Anonyme. A member of the American Artists Congress, Lozowick treated socially relevant themes during the 1930s, although he is particularly known for his geometrically formulated lithographs of urban cityscapes. In his later work a romantic impulse occasionally surfaces.

Bruno Lucchesi
born Italy 1926

Hammock

1972

bronze on marble base
21 x 40½ x 9½ (53.3 x 103 x 24.2)
provenance: Forum Gallery, New York, 1974

Lucchesi, who studied at the Institute of Art in Lucca and later in Florence, is a writer on sculptural techniques as well as a sculptor. In 1957, he moved to New York and has since become known for genre sculpture in terra cotta and bronze. Although frequently compared with John Rogers, the creator of the well-known Rogers groups, Lucchesi seldom incorporates the narrative elements typical of the nineteenth-century American. Instead he shows people waiting, sleeping, bathing, or otherwise going about the business of their daily lives, and portrays the mannerisms characteristic of their activities. Catching a brief expression of boredom, the momentary gesture of a yawn, or the fluid movement of a woman hanging out wash, Lucchesi achieves a balance between sympathy and caricature that is at once poetic and immediate, and often humorous.

Ann McCoy
born 1946

Ach rèalt ina ga an uisge
1979
pencil and colored pencil on acrylic-toned gesso
on paper mounted on canvas
81½ x 145⅛ (207 x 368.6)
provenance: Brooke Alexander, Inc., New York,
1980

Ann McCoy received her B.F.A. from the University of Colorado in 1969 and an M.A. in sculpture and drawing from the University of California at Los Angeles in 1972. Her first works were wooden sculptures of mountains; later, she made cast resin sculptures of icebergs. In the early 1970s, after she abandoned sculpture for monumentally scaled drawings done in colored pencil, her success came fast. By the mid 1970s she was a nationally acclaimed artist with a number of solo shows to her credit. In 1974 McCoy first exhibited drawings of underwater explorations, for which she is largely known today. A scuba diver since 1968, McCoy works from photographs of the plant and animal life of the subaquatic world, creating drawings and hand-colored lithographs distinctive for their meticulous detail and surrealistic mood.

Keith McDaniel
1948–1986

Arlington Street
1981

acrylic on canvas
31⅞ x 48 (81 x 121.9)
provenance: Main Street Gallery, Nantucket,
1981

A longtime resident of Boston, McDaniel painted compositions based on the city's diverse architectural styles. Concerned with both interior and exterior space, McDaniel sought out unusual structures—a fortress on an island in Boston harbor, wharf buildings on Nantucket Island—finding a unique harmony in their aging architectural forms. Typically unpopulated, McDaniel's landscapes retain strong geometric overtones. By simplifying lighting patterns and stressing asymmetry in both structure and viewpoint, McDaniel imbued his scenes with an air of mystery and implicit narrative.

Loren MacIver
born 1909

Defense de Stationner
1963

oil on canvas
36¼ x 72⅞ (92.1 x 185.1)
provenance: Pierre Matisse Gallery, New York,
1981

In 1919, at the age of ten, MacIver attended
Saturday classes at the Art Students League in
New York—her only formal instruction in paint-
ing. When she was twenty-five she married poet
Lloyd Frankenberg and settled in Greenwich
Village. Although she continued painting, she
never expected to make a career as an artist.
From 1936 until 1939 she worked on the WPA,
and in the 1940s, as her reputation grew, she
received commissions to do several murals for
shipping lines and magazine covers. After her
first trip to Europe in 1948, MacIver painted
with increasingly brilliant colors. In 1966 she
returned to Paris, where she remained for four
years and worked in Provence for several winters.
New York City, where she has spent much of
her life, and her recurrent interest in nature
have been the principal themes of MacIver's art,
which has ranged stylistically from extreme real-
ism to highly abstract designs.

Oronzio Maldarelli
1892 Italy–1963 USA

Adrian
1957

bronze on wood base
56¾ x 21½ x 19¼ (144.1 x 54.6 x 48.9)
provenance: Paul Rosenberg & Co., New York,
1959

Maldarelli immigrated to the United States from
his native Naples as a child. At fourteen he took
lessons in drawing and clay modeling, and after
two years began study at the National Academy
of Design with Leon Kroll, Ivan Olinsky, and
Hermon McNeil. In 1912 he entered the Beaux-
Arts Institute, where Jo Davidson and Elie Na-
delman became particular influences. A classicist
with modern tendencies, Maldarelli's early ab-
stract work reflected a brief flirtation with primi-
tivism; but in 1935 he became dissatisfied with
the separation of form and content and turned to
figural work. Maldarelli is best known for sculp-
tures of female forms in which volume, mass,
and contour are overriding concerns. A teacher
at Columbia University for many years, Malda-
relli received a number of sculptural commis-
sions throughout the 1940s and 1950s.

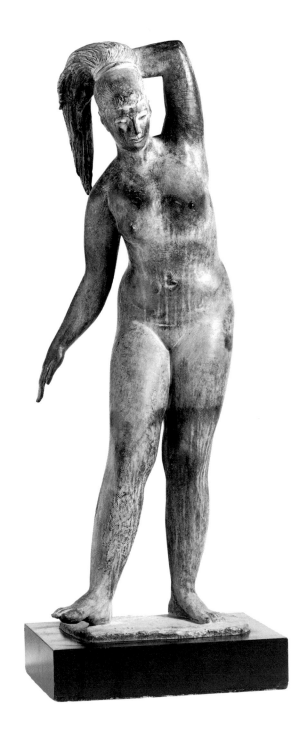

Marisol
born France 1930

Untitled
1960

crayon and pencil on paper
14⁷/₁₆ x 21⁵/₁₆ (36.6 x 54.1)
provenance: Sidney Janis Gallery, New York,
1972

Marisol Escobar is a Parisian-born Venezuelan who has lived in New York since the 1950s. She studied at the Ecole des Beaux-Arts in Paris in 1949 and at both the New School for Social Research and the Hans Hofmann School from 1951 to 1954. Marisol's carved and painted sculpture became associated in the early 1960s with Pop Art, although her sculpture has little to do with the notions about mass production and signage for which Pop is famous. Instead, her work satirically commented on contemporary social and political attitudes and depicted subjects ranging from socialites, celebrities, and political figures to a migrant dust bowl family in search of work. After several years abroad, Marisol returned to the United States in the early 1970s and concentrated on beautifully crafted mahogany sculpture of sharks, barracudas, and other forms of marine life all bearing the image of the artist's face. In recent years, in mixed media assemblages, Marisol has portrayed such creative legends as Georgia O'Keeffe and Martha Graham and has also imaginatively adapted imagery from Old Master paintings.

Reginald Marsh
1898 France–1954 USA

George Tilyou's Steeplechase
1932

oil and egg tempera on linen mounted on
fiberboard
30⅛ x 40 (76.5 x 101.8)
provenance: Frank K. M. Rehn, Inc.,
New York, 1955

Although both of his parents were artists, Marsh
himself did not plan to be a painter, and after
graduation from Yale in 1920, he moved to New
York to become an illustrator. He got a job
doing cartoon reviews of vaudeville and bur-
lesque shows for the *New York Daily News* and
in 1925, when the *New Yorker* was founded,
Marsh was one of its original contributors.
Marsh continued to submit drawings to *Vanity
Fair, Harper's Bazaar, Esquire, Fortune,* and
Life even after he determined to be a painter in
the 1920s, and he also taught intermittently at
the Art Students League, where he had studied
in the early 1920s. A frequent traveler to Eu-
rope, Marsh adapted the techniques and spatial
arrangements of Old Master painting to his own
canvases, but continued to prowl New York's
back streets, sketching Bowery bums, burlesque
queens, and the crush of people around Union
Square and 14th Street. He used compositional
formats drawn from Italian Mannerist and Ba-
roque masters in his scenes of tawdry New York
life, and like his friends Isabel Bishop, Kenneth
Hayes Miller, and Edward Laning, Marsh
brought an underlying sympathy for the down-
trodden to his often satiric compositions.

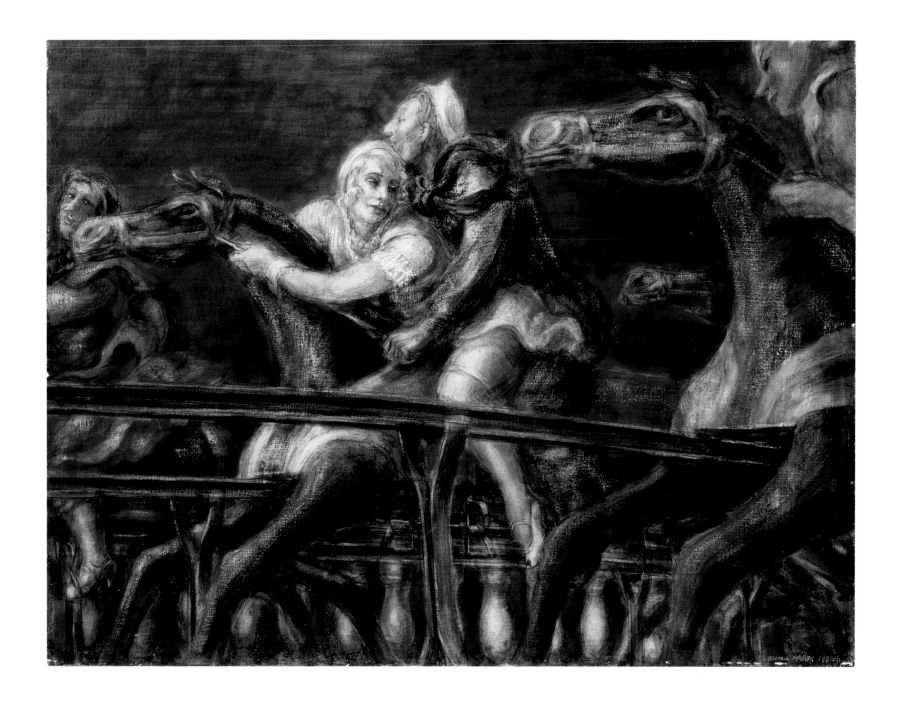

Reginald Marsh
Coney Island Beach
1951

oil on fiberboard
24¾ x 30 (62.7 x 76.1)
provenance: Frank K. M. Rehn, Inc., New
York, 1955

Coney Island Beach
1953

egg tempera and ink on fiberboard
18 x 24 (45.7 x 61)
provenance: the artist, 1953

Richard Mayhew
born 1934

Nature Solitude II
1969

pen and ink on paper
17⁹⁄₁₆ x 23¹³⁄₁₆ (44.6 x 60.5)
provenance: Midtown Galleries, New York, 1973

Currently a professor at Pennsylvania State University, Mayhew studied initially at the Art Students League and with Edwin Dickinson and Reuben Tam at the Brooklyn Museum School. He visited Paris in 1961, having just spent two years in Florence on a John Hay Whitney Fellowship, and lived for a time in Holland before returning to the U.S. Primarily a landscape painter, Mayhew has also organized and participated in multimedia performances and directed community outreach arts programs. In the 1960s Mayhew painted landscapes in close tonal harmonies and gradually diffused recognizable forms until they disappeared entirely in his paintings of the 1970s. Since 1975, however, he has driven across the U.S. five times to observe the mood and space of the American landscape, and now, working with an intensified palette, Mayhew recreates an exuberant sense of vast space within the canvas.

Michael Mazur
born 1935

Mirror #1
1969

airbrushed acrylic on paper
44¹⁄₁₆ x 30⅛ (112 x 76.5)
provenance: Terry Dintenfass, Inc., New York,
1972

A humanist concerned with social and environ-
mental issues, Mazur has experimented with
nonrepresentational imagery, but has consistently
remained apart from avant-garde movements. He
studied at Amherst and with Leonard Baskin in
Northampton, Massachusetts, and did graduate
work with Gabor Peterdi and Bernard Chaet at
Yale. Following three years as a teacher at the
Rhode Island School of Design he joined the
faculty at Brandeis University in 1965. From
1961 to 1966 he worked on a series of prints—
based on visits to a mental facility in Provi-
dence—many of which comment on humanity
robbed of history, age, clothes, and social stand-
ing. The influence of Rembrandt, Goya, Dau-
mier, Munch, and Kollwitz can be discerned in
Mazur's early work, although during the late
1960s thematic concerns gave way to experimen-
tation with graphic media. Highly expressionistic
in handling and color, and ambiguous in the-
matic relationships, Mazur's recent paintings ex-
plore disturbing narrative images of implied vio-
lence and its emotional residue.

Richard Merkin
born 1938

Madame Bricktop Sees St. Martin Go Through the Room
1972

tempera on paper mounted on fiberboard
48 x 72 (121.9 x 182.8)
provenance: Terry Dintenfass, Inc., New York, 1973

Merkin did graduate work in fine arts at Michigan State University and the Rhode Island School of Design after earning his B.F.A. at Syracuse University. Since 1970 he has served as an adjunct professor at the Rhode Island School of Design, although he currently resides in New York City. In paintings, assemblages, and collages, Merkin conjures popular scenes from America of the 1920s, 1930s, and 1940s, choosing subjects—from the Cotton Club to Mickey Mouse to Luna Park—that are witty, often eccentric, combinations of movie stars, sports heroes, and personal references. Although there is a realistic basis behind his themes, Merkin avoids descriptive handling of his subjects; instead, through cutout shapes and overlays of paint and line, he works toward formal balances and juxtapositions that belie the humor of his titles.

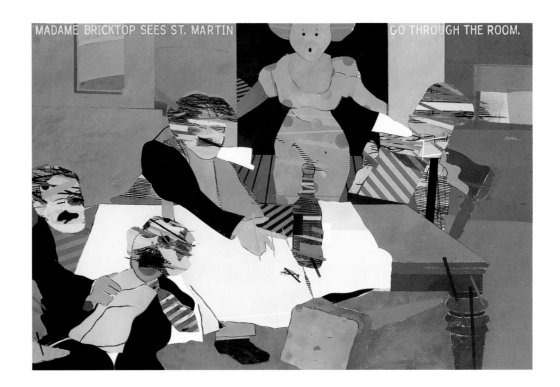

Kenneth Hayes Miller
1876–1952

Bargain Hunters

1940

oil on canvas
30⅞ x 36⅛ (78.4 x 91.8)
provenance: Mrs. Howard C. Smith, Jr. (the
artist's daughter), 1957

During the forty years that Kenneth Hayes
Miller taught at the Art Students League, he
inspired a generation of American painters to
find the sources of their art in both the Renais-
sance and contemporary urban life. Miller him-
self had sought traditional academic training
from Kenyon Cox and H. Siddons Mowbray at
the Art Students League and had worked with
William Merritt Chase at the New York School
of Art. After a trip to Europe he joined the staff
at the New York School in 1899, and in 1911
began his teaching career at the League. Miller's
early romantic paintings revealed the influence
of his friend Albert Pinkham Ryder, but during
the second decade of the century he turned to
the Renaissance compositional devices and tech-
nical media later adopted by Reginald Marsh,
Paul Cadmus, Edward Laning, and other Miller
protégés. For his subjects, Miller looked to 14th
Street and Union Square. His sales girls and
shoppers seem frozen in space, the forms of their
bodies described in terms of interlocking ovals
that are contained within carefully conceived
contour lines.

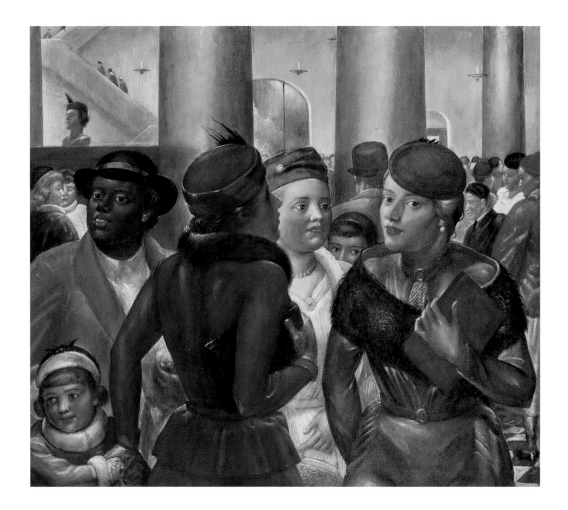

Roy Moyer
born 1921

Lovers in the Snow II
1980

oil on canvas
28 x 30⅛ (71 x 76.5)
provenance: Carl Battaglia Galleries, New York, 1980

Groomed from childhood for a life as a concert pianist, Roy Moyer is essentially self-taught as a visual artist. He received undergraduate and graduate academic degrees from Columbia University and, following military service during World War II, studied at the University of Oslo. From 1947 until 1950 Moyer lived in Salonica, Greece, where his first exhibition was held. Moyer served as director of the American Federation of Arts from 1963 until 1972, and is currently chief of art and design for UNICEF. A thematic traditionalist, Moyer paints still lifes, landscapes, and figures with a reductive sense of form, and emphasizes the rhythmic contours rather than details of his subjects. If Moyer's work has a visual precedent, it is the expressive use of line and color characteristic of Edvard Munch, although Moyer seldom seeks the psychological intensity found in the Norwegian expressionist's work. The glowing hues of Moyer's recent paintings create illusions of space through color alone.

Roy Moyer

Diagonal Shaft of Light
1967

oil on canvas
29¹/₂ x 29¹/₂ (74.9 x 74.9)
provenance: Gift of Dr. Karl Lunde, 1993

George Murphy
born England 1947

Cliff Road Hitching Post
1982

oil on canvas
30⅛ x 30⅛ (76.5 x 76.5)
provenance: Sibley Galleries, Nantucket, 1982

George Murphy began to paint late in 1970, while attending the University of York, England, although he had never received formal artistic training. Seven years later, his car packed with belongings and an easel strapped to its roof, Murphy set out for Florence, Italy, where he remained for three years. Working from a studio overlooking the Piazza Santa Croce, he portrayed bushes, hedges, and trees, "seeking to isolate them as objects with a certain 'presence.'" In the spring of 1979 he made his first trip to the United States, and the following year moved to Nantucket, his home and inspiration for the past six years. Murphy is currently interested in neoclassical architecture as subject matter for his paintings and seeks consistently to simplify and order his imagery.

111

Louise Nevelson
1900–1988

Sky Totem
1956

wood construction
70¾ x 9⅜ x 5½ (179.7 x 23.8 x 14)
provenance: Grand Central Art Galleries,
New York, 1958

Nevelson came to the United States as a child
with her family, settling first in Rockland, Maine.
At age twenty she went to New York to study
voice and drama as well as painting and drawing.
She attended the Art Students League in 1929
and 1930, then traveled to Munich to study with
Hans Hofmann. Two years later she was working
as an assistant to Diego Rivera, who introduced
her to pre-Columbian art; her first solo show in
1941 featured terra cotta and wood sculptures
based on Mayan and other primitive imagery.
Not until the mid 1950s did Nevelson's far-
ranging interests coalesce into dramatically
conceived constructions for which she became
world-renowned. Nevelson's sculptures are about
myth and mystery, and although she took motifs
from the world around her, she stated that she
identified with ideas "more than with nature."
Although she was fascinated with the living
quality of wood, in the 1960s she added plastics
and formica to her repertoire of media and in the
1970s began to create monumentally scaled
pieces in aluminum and steel.

Howard Newman
born 1943

Temptress
1978

bronze
14 x 12¼ x 14 (35.8 x 31.1 x 35.8)
provenance: Cordier & Ekstrom, Inc.,
New York, 1979

Newman studied at Miami University of Ohio
and received an M.F.A degree from the Rhode
Island School of Design in 1971, the year he
won a Fulbright grant to work in Italy. Although
he has recently exhibited paintings, Newman is
best known for drawings and bronzes that are
reminiscent of Umberto Boccioni's Futurist
sculpture and Duchamp-Villon's mechanical ab-
stractions. Newman combines elements of hu-
man figures and machines into tightly interlock-
ing geometric shapes that he assembles from
separately cast pieces. Until recently he em-
ployed smooth, highly polished surfaces and uni-
form patinas. In his new sculpture, however,
Newman permits surfaces to show marks of their
original development in clay, a major stylistic
transformation from the mechanical flawlessness
of his earlier work.

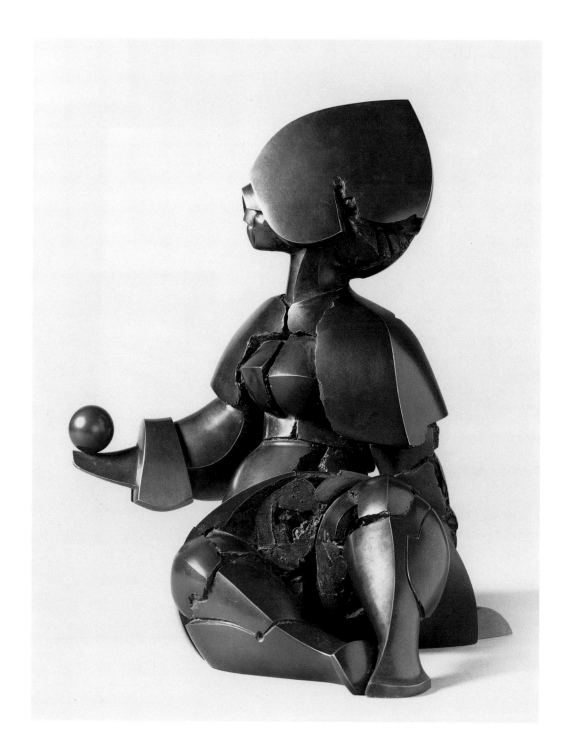

Leigh Palmer
born 1943

Striped Tablecloth with Two Apples
1983

oil on linen
36⅛ x 50 (91.8 x 127.1)
provenance: Main Street Gallery, Nantucket,
1983

After graduating from the Rhode Island School of Design, where he studied with Richard Merkin, Palmer spent two years in Peru with the Peace Corps. On his return to the United States in 1968, he did graduate work in film studies at Boston University and made educational films for several years before moving to a Pennsylvania farm. He worked as a builder and contractor to support himself until about 1982, and since then has been painting full time. Initially fascinated with the work of Gene Davis, Kenneth Noland, and other members of the Washington Color School, Palmer did hard-edged color field canvases early in his career. Since the early 1980s, however, he has concentrated on still life, setting simple arrangements of fruit and objects into interior spaces and exploring dramatic patterning of light and shadow.

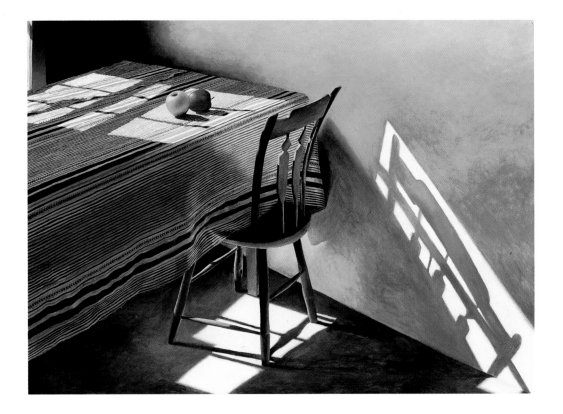

William C. Palmer
1906–1987

The Last Snow
1956

oil on canvas
40 x 44 (101.6 x 111.8)
provenance: Midtown Galleries, New York, 1956

Palmer took classes with Boardman Robinson and Kenneth Hayes Miller at the Art Students League and in the 1920s studied fresco at the Ecole des Beaux-Arts in Paris. Much of Palmer's work during the late 1930s was devoted to the various government art programs; he won a coveted commission to paint murals for the Post Office Department building in Washington, D.C., and was later appointed supervisor of the WPA's mural division in New York City. From 1941 until his retirement in 1973, he served as director of the art school at Munson-Williams-Proctor Institute in Utica. Palmer was a painter of the American Scene who portrayed the rolling plains and expansive skies of his native Iowa during the 1930s and 1940s. In the 1950s he began exploring the moods, atmosphere, and light of New York's rural landscape, which he interpreted through abstract planes and closely graded colors.

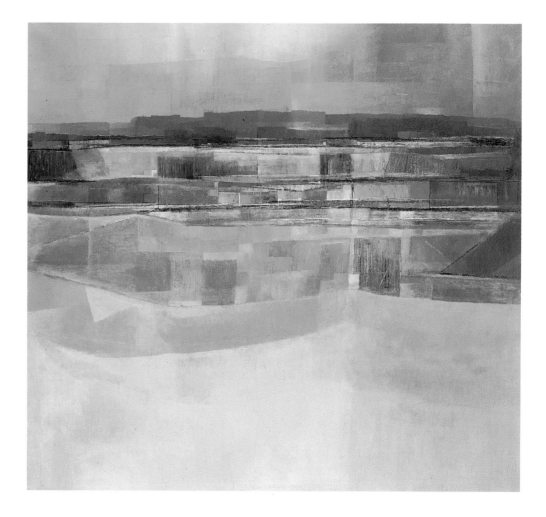

Robert Andrew Parker
born 1927

Parachutists
1968

pen and ink and watercolor on paper
26⅜ x 37⅛ (67 x 94.1)
provenance: Terry Dintenfass, Inc., New York,
1971

Parker attended the school of the Art Institute of
Chicago from 1948 until 1952 and worked dur-
ing the following months at the Skowhegan
School of Painting and Sculpture in Maine and
at Stanley William Hayter's Atelier 17 in New
York. Since his first solo show in 1954, Parker
has exhibited extensively, and his credits include
set designs for opera and film as well as book
illustrations. In his watercolors Parker combines
areas of pure color with design conceived in
terms of silhouette and shape. He takes his sub-
ject matter mostly from the natural world—dogs,
trees, mountains, people, birds—and condenses
and simplifies imagery with a swift, expressionis-
tic technique. During his career Parker has
worked in such distinctive locales as Arles and
Saint-Rémy in France and the Himalayas, where
a 1981 walking tour provided the subjects for a
series on landscapes and fellow trekkers.

Guy Pène du Bois
1884–1958

Shovel Hats

1923

oil on plywood

20 x 14¾ (50.7 x 37.5)

provenance: Charles Downing Lay, Kraushaar Galleries, New York, 1957

During the first years of this century, Pène du Bois worked as a monitor in Robert Henri's class at the Art Students League, but he never adopted the Ash Can subject matter favored by Henri-circle artists. Instead, Pène du Bois painted the affluent society at play—at the opera, the race track, in chic night clubs, or simply walking down Fifth Avenue. His highly stylized paintings depict vignettes of manners, what he called "symbols of sophistication." Pène du Bois made his artistic debut at the Paris Salon in 1905, but returned to New York the following year to work as a reporter for the *New York American*. A writer on art as well as a painter, Pène du Bois edited the issue of *Arts and Decoration* devoted to the 1913 Armory Show and served intermittently as editor of the magazine for the following seven years. In 1924 he moved to a small town outside of Paris to concentrate on painting, but on his return to the United States in 1930 was again occupied with writing and soon published monographs on John Sloan, William Glackens, Edward Hopper, and Ernest Lawson.

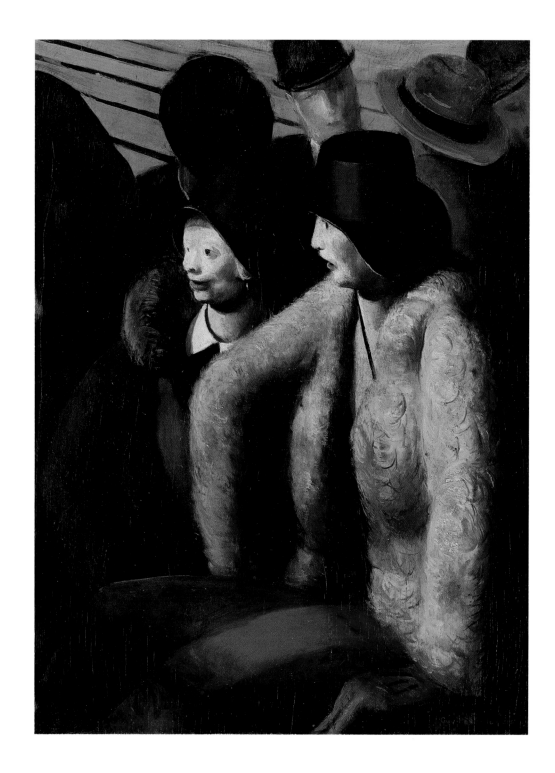

Bernard Perlin
born 1918

The Farewell

1952

casein on fiberboard
34⅛ x 47⅛ (86.7 x 119.7)
provenance: Catherine Viviano Gallery,
New York, 1955

Although Perlin studied at the New York School
of Design and at the National Academy of De-
sign, he said that William Palmer at the Art
Students League was the first teacher who made
any sense to him. During the war Perlin worked
for the graphics division of the Office of War
Information along with Ben Shahn, who became
a major influence on the young Perlin. He then
became an artist-correspondent for *Life* and later
worked for *Fortune*. In 1946, still under Shahn's
influence, Perlin began to paint seriously. Social
comment was often implicit in his work at this
time, and he was especially concerned with de-
picting the plight of minority groups and the
poor. From 1948 until 1954 he lived in Italy,
supported partially by Fulbright and Guggen-
heim fellowships. His return to the United States
marked a change in Perlin's technique and sub-
ject matter. Color replaced line as his primary
expressive device, and the isolation of the indi-
vidual became a predominant thematic concern.

Joseph Raffael
born 1933

Watercolor #28

1974

watercolor on paper
26¹⁄₁₆ x 20⅛ (66.2 x 51)
provenance: Nancy Hoffman Gallery, New York, 1974

Raffael had his first solo show in 1958 and since that time has exhibited widely in the United States and abroad. Raffael's works of the mid 1960s—surreal combinations of imagery cut from magazines—were thematically concerned with "pain, suffering, and cut-off things" and bear little resemblance to either the work of his Yale professors Josef Albers and James Brooks or to Raffael's more recent compositions. In the 1960s Raffael began painting streams and isolated flora and fauna in natural settings, working from photographs to capture momentary and spontaneous occurrences in nature. In these paintings Raffael synthesizes realism and abstraction; he crops external references to natural scale and distance, so that a single image often fills the picture plane. In his recent work, Raffael shows the entire sweep of a garden rather than close-up individual images and consciously organizes his subjects to produce dramatic effects of contrast and brilliance.

Paul Resika
born 1928

The Great Rocks
1970

oil on canvas
24⅛ x 30⅛ (61.3 x 76.5)
provenance: Peridot Gallery, New York, 1971

While still a teenager Resika studied with Sol
Wilson and for three years with Hans Hofmann.
He then lived and painted in Italy, returning to
the United States in 1953. He served as an
adjunct professor of painting and drawing at
Cooper Union from 1966 until 1977 and has
also taught at the Art Students League, at the
Skowhegan School, and in the graduate program
of the University of Pennsylvania. In 1972 he
served as artist-in-residence at Dartmouth Col-
lege. Between his first solo show in 1948 and his
second, sixteen years later, Resika moved from
abstraction to landscape and figure paintings that
combine the balance of the French classic mas-
ters he admires with a structural solidity learned
from Cézanne. In 1958 Resika began working
directly from nature, exploring single subjects
under varying conditions of light and mood.
More recently, Resika has simplified his compo-
sitions, opened up space, and reduced his pal-
ette.

Michael Robbins
born 1949

Dawn
1975
oil pastel on paper
23¼ x 29³⁄₁₆ (58.9 x 74)
provenance: Gladstone/Villani, Inc., New York, 1979

Robbins received a B.F.A. degree from Cooper Union in 1970 and spent the following year as a teaching fellow at Syracuse University. Since the mid 1970s his paintings, drawings, and block prints have been exhibited extensively in the United States and abroad, and in 1985 he received a painting grant from the National Endowment for the Arts. Robbins is a keen observer of the changing moods and atmospheres of the city. He sees the people of New York in quick, impressionistic terms, and seeks to capture the speed and motion of the the streets. He is especially concerned with the changes in light and color that occur at different times of the day and during different seasons, and expresses in his work the quick "moments of realization [one has] in the passage through the physical world."

Hugo Robus
1885–1964

One and Another

1934

bronze on wood base
28¾ x 43⅞ x 23⅜ (73 x 111.5 x 59.4)
provenance: the artist, 1957

After four years at the Cleveland School of Art Robus went to New York City in the fall of 1907 to study painting at the National Academy of Design. In 1912 he left for France where he worked with noted sculptor Emile Antoine Bourdelle at the Académie de la Grande Chaumière. On his return to New York, however, Robus again painted, experimenting with the bright prismatic colors and fragmented space characteristic of Italian Futurism. In 1920 Robus gave up painting for sculpture, although his first solo show of three-dimensional work did not occur until 1949, when Robus was sixty-four. In his sculpture Robus explored simple themes—a woman washing her hair, a girl reading, a mother with her child. Except for a brief period during the 1940s, when he was concerned with tactile surface effects, Robus created stylized figures with highly polished surfaces and sinuous contour lines that adroitly balance positive and negative space.

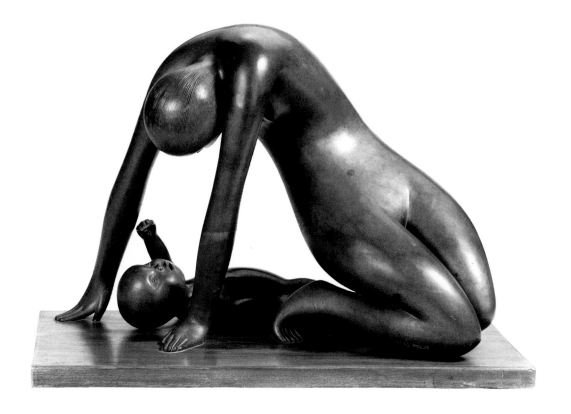

Theodore Roszak
1907 Poland–1981 USA

Thistle in the Dream (To Louis Sullivan)
1955–56

cast and welded steel
59⅛ x 40½ x 30 (150.2 x 102.9 x 76.3)
provenance: Pierre Matisse Gallery, New York,
1956

After art school, Roszak received a fellowship to
go to Europe in 1929. He set up a studio in
Prague, and on trips to France, Germany, and
Austria learned of Purism and Constructivism
and became fascinated with the Bauhaus princi-
ples of the integration of art and life. After two
years, Roszak returned to New York and in 1938
taught at the Design Laboratory, an experiment
to transplant Bauhaus principles and methods to
the United States. Between 1936 and 1945,
Roszak created constructions—three-dimensional
and wall-mounted sculpture in which he elimi-
nated all subject matter other than the uncom-
promising geometric form of the pieces them-
selves. Around 1945, however, Roszak
abandoned Constructivism because it reflected a
view of the world he took to be falsely harmoni-
ous. Seeking to reintegrate content into his work,
Roszak began welding and discovered that sur-
face effects achieved by accident suggested a
world of meaningful associations. The forms of
his late work, he said, "are meant to be blunt
reminders of primordial strife and struggle, remi-
niscent of those brute forces that not only pro-
duced life, but in turn threatened to destroy it."

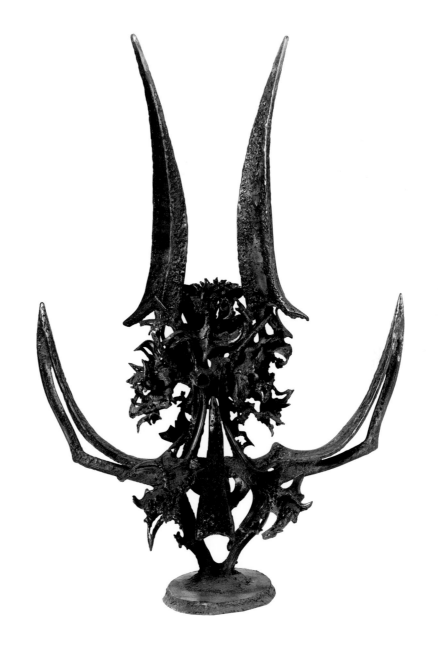

Cornelis Ruhtenberg
born Latvia 1923

Sewing a Doll I
1970–72

acrylic on canvas
43¾ x 34⅛ (111.2 x 86.7)
provenance: Forum Gallery, New York, 1974

Cornelis Ruhtenberg studied at the Hochschule
für Bildende Kunst in Berlin from 1941 until
1946 and two years later immigrated to the
United States. Ruhtenberg is primarily a painter
of figures, but she explores neither psychological
insight nor the appearance of her subjects. In-
stead she seeks pure, essential meaning and de-
picts her sitters caught in their own contempla-
tive worlds. She paints in muted acrylic glazes—
tawny golds, bisques, and beiges—and uses her
subjects as vehicles for chromatic harmonies. Al-
though detailed life studies are frequently the
subjects of her drawings, and faithfully rendered
furniture and objects populate her canvases, the
figures in Ruhtenberg's paintings are executed
with a loose, painterly stroke.

Robert Sarsony
born 1938

The Starter Told Parker to Go Around
1971

oil on fiberboard
30 x 40 (76.3 x 101.6)
provenance: A.C.A. Galleries, New York, 1971

Robert Sarsony is a self-taught painter and print-maker who began exhibiting in local shows in New Jersey in 1963. The following year he made his New York debut in a group show at Allied Artists. From 1969 until about 1974 he did a series of paintings based on book and magazine illustrations—"pop antiques," he calls them—from the 1920s through the 1940s. Subjects ranged from silent movie photographs and pictures of important historical events to reproductions taken from period children's books. In the corners of his canvases Sarsony often paints small images copied from cards found in cigarette packages and cereal boxes during the first half of this century. In doing so he follows in the steps of the nineteenth-century *trompe l'oeil* artists who depicted visiting cards that looked as though they were tucked under the edges of their paintings' frames. More recently Sarsony has portrayed figure and landscape subjects with an attention to light effects that gives his canvases an impressionistic air.

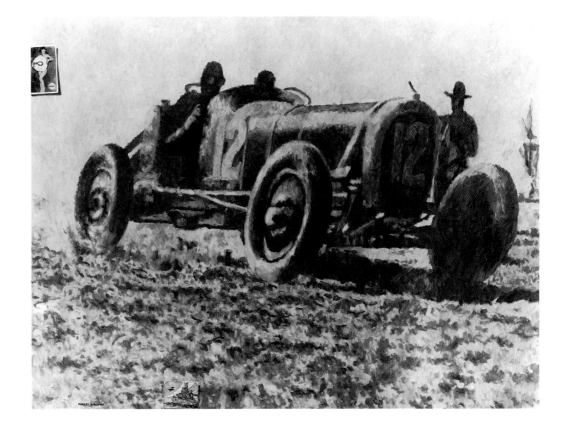

Katherine Schmidt
1898–1978

Man with Coffee Cup
1935

pen and ink and pencil on paper
11¼ x 7¹¹⁄₁₆ (28.6 x 19.5)
provenance: Zabriskie Gallery, New York, 1973

At age thirteen Katherine Schmidt persuaded her reluctant parents to allow her to attend Saturday classes at the Art Students League in New York. After completing high school she worked with Kenneth Hayes Miller at the League and there met Yasuo Kuniyoshi, to whom she was married for thirteen years. During the twenties and thirties Schmidt exhibited frequently in New York. Press reviews of her meticulously rendered still lifes and landscapes of the 1920s, and of subsequent portrayals of the homeless and unemployed, were generally favorable. Around 1939, however, Schmidt became dissatisfied with her work and refused solo exhibitions until 1961, when she accidentally discovered a motif that concerned her for the remainder of her life. Having thrown a crumpled paper towel on a table, she returned to find a "beautiful piece of paper lying there." In her late still lifes of discarded paper and dead leaves Schmidt continued to exhibit the mastery of descriptive realism that had characterized her early work.

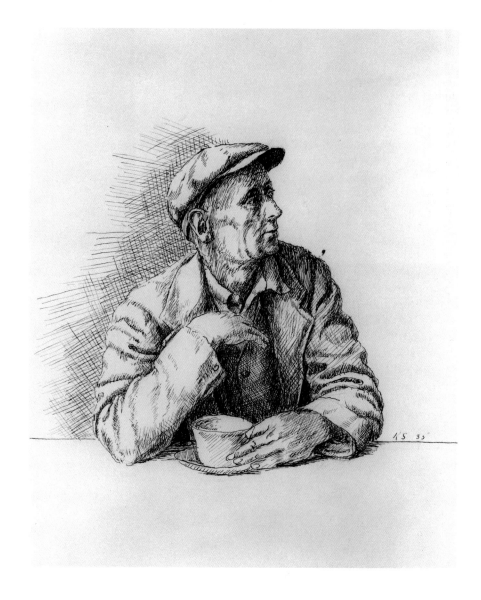

Ben Shahn
1898 Lithuania–1969 USA

After Titian
1959

tempera on fiberboard
53½ x 30½ (136 x 77.5)
provenance: The Downtown Gallery, New York, 1959

Ben Shahn immigrated to the United States as a child and was apprenticed to a lithographer after finishing elementary school. In the 1920s, he studied at New York University and City College, and very briefly at the National Academy of Design. Shahn's first major success came with the 1932 exhibition of his series *The Passion of Sacco and Vanzetti*. Shahn once said that he paints two things, "what I love and what I abhor," and during the Depression years his scenes of children playing in concrete urban parks, and of miners and construction workers engaged in their trades, reflect his admiration for the working American and his abhorrence of injustice and oppression. Throughout the 1930s Shahn worked for various government programs, and when the United States entered World War II, he joined the Graphic Arts Division of the Office of War Information, although only two of the many posters he designed were published. In the 1940s, Shahn turned to what he called "personal realism." His late work is often symbolic, allegorical, or religious and reflects his belief that "if we are to have values, a spiritual life, a culture, these things must find their imagery and their interpretation through the arts."

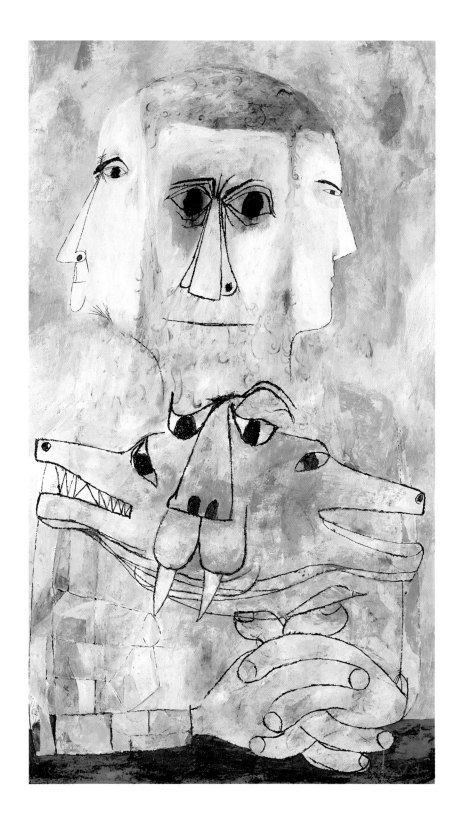

Honoré Sharrer
born 1920

Tribute to the American Working People
1951

oil on composition board
frame: 38⅝ x 77⅜ (98.1 x 196.5)
provenance: M. Knoedler & Co., New York,
1957

Honoré Sharrer took her first painting lessons
from her mother, who had been a pupil of
George Luks. She studied at the California
School of Fine Art and at Yale, but left because
of her feeling that "the school's academic disci-
pline was . . . incapable of stimulating the artist
to seek what was valuable to express." During
World War II Sharrer worked as a welder in a
San Francisco shipyard, then came to New
York, where her paintings were featured in the
Museum of Modern Art's *Fourteen Americans*
exhibition in 1946. Over the course of her career
Sharrer has made dramatic changes in subject
matter and to some degree in technique. In her
early "social realist" paintings she depicted
American working people, then went through a
surrealist phase in which she twisted "everyday
basic things" to make them funny. In her recent
work she explores myth and fairy tale and com-
bines disjunctive imagery to free herself from
"the punishment of 'realism.' "

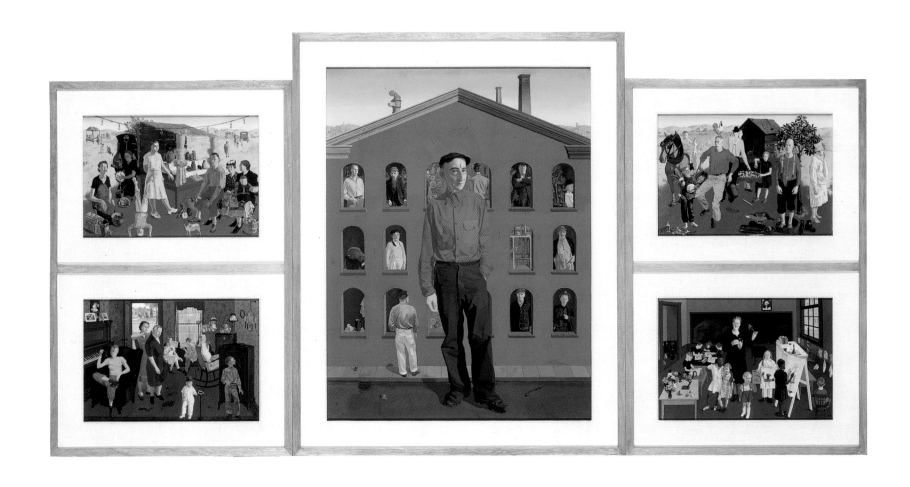

Raphael Soyer
1899 Russia–1987 USA

Annunciation
1980

oil on linen
56 x 50⅛ (142.5 x 127.3)
provenance: Forum Gallery, New York, 1984

Raphael Soyer was a painter, draughtsman, and
printmaker who believed that "if art is to survive,
it must describe and express people, their lives
and times. It must communicate." From an early
age Soyer and his brothers Moses and Isaac were
encouraged to draw by their father, a teacher of
Hebrew literature and history. Forced to leave
Russia in 1912, they immigrated to the United
States and settled in Brooklyn. In the mid 1920s,
having studied at Cooper Union, the National
Academy of Design, and the Art Students
League, Soyer painted scenes of life on New
York's east side. His portrayals of derelicts,
working people, and the unemployed around
Union Square during the Depression reveal more
of a poignant vision of the human condition than
the art of social protest popular with many of his
contemporaries. Throughout his life Soyer
painted people—his friends, himself, studio
models—with an unerring eye for intimacy
and mood.

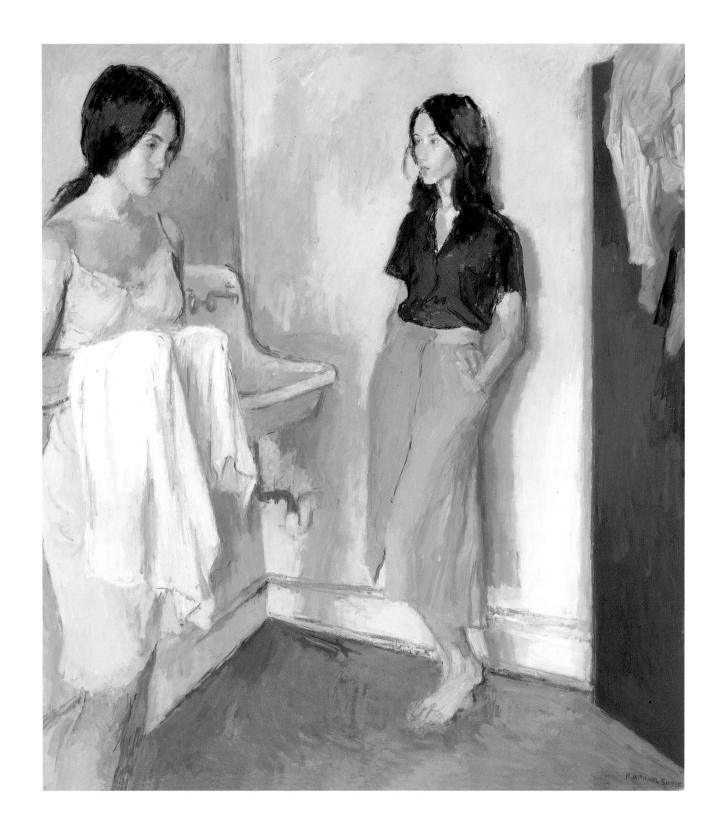

131

Saul Steinberg
born Romania 1914

Sag Harbor
1969

watercolor, rubber stamp, and ink on paper
30 x 40 (76.2 x 101.6)
provenance: Betty Parsons Gallery, New York,
1973

A draughftsman who does watercolors, collages,
assemblages, and oil paintings, Saul Steinberg is
best known as the *New Yorker* cartoonist whose
fanciful people and animals uncannily capture
the masquerades of modern life. Using a cast of
characters and elements that includes cats, croc-
odiles, letters and punctuation marks, architec-
tural monuments, and household equipment,
Steinberg finds riddles more truthful than an-
swers. Masked by the wit of his visual and verbal
puns is social comment; Steinberg considers
himself a "writer in line" and calls drawing a
way of "reasoning on paper." He continually
questions the nature of people and things and
uses his cartoons to meditate on a limitless range
of issues. Steinberg studied for a year at the
University of Bucharest, but in 1933 transferred
to the architectural school at the Polytechnic
University in Milan. In 1936 he began publish-
ing cartoons in an Italian humor magazine, and
soon after receiving his architecture degree in
1940, Steinberg was publishing regularly in the
New Yorker. The following year he immigrated
to the United States and during World War II
served in the U.S. Navy.

Jon Stroup
born 1917

The Gardener
1979

oil on canvas
39⅞ x 40⅛ (101.3 x 101.9)
provenance: the artist, 1979

Aside from Saturday morning classes at the Cleveland School of Art, Stroup is a self-taught artist. He spent most of his adult life as a magazine editor, first at *Town & Country*, then at *House and Garden*, and began to draw only after moving to Nantucket Island. Working initially in felt-tipped pen, Stroup depicted the flat Nantucket landscape, but turned to watercolor after his first exhibition. On the recommendation of a friend, who explained that the drawings failed to sell because Stroup used no color, he bought a set of watercolors. In 1976, having found acrylic an unsatisfactory medium, Stroup began working in his now-preferred medium of oil. Currently concerned primarily with the figure, Stroup creates a sense of enigmatic relationships among the small groups of people he portrays.

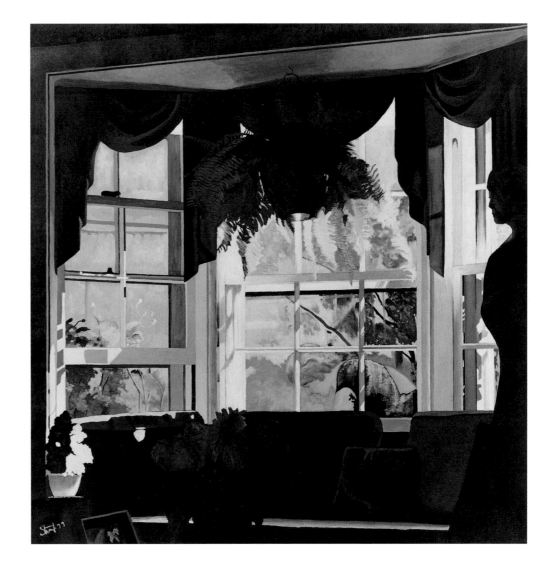

William Thon
born 1906

Pine Trees
1955

watercolor and ink on paper
22³⁄₁₆ x 30 (56.3 x 76.3)
provenance: Midtown Galleries, New York, 1955

Thon quit school at age sixteen to work as a
bricklayer's assistant, and with his first earnings
bought paint and brushes. He was about twenty
when a friend suggested he enroll at the Art
Students League, but after a month of drawing
from plaster casts, he left the League and went
into business as a designer and builder of win-
dow displays. In 1933 Thon set sail on a sixty-
foot schooner looking for buried treasure. Al-
though the project was abandoned after seven
months, Thon created a wealth of sketches dur-
ing his sea venture that he used in painting on
his return. After a stint in the navy during
World War II Thon settled in Port Clyde, a
small fishing village on the Maine coast. There
he re-creates on canvas and paper his emotional
responses to the rocky coastline, turbulent sea,
and wooded forests. Thon spent 1947 at the
American Academy of Rome and returned with
a Prix de Rome in 1950. In 1956 he was artist-
in-residence at the American Academy.

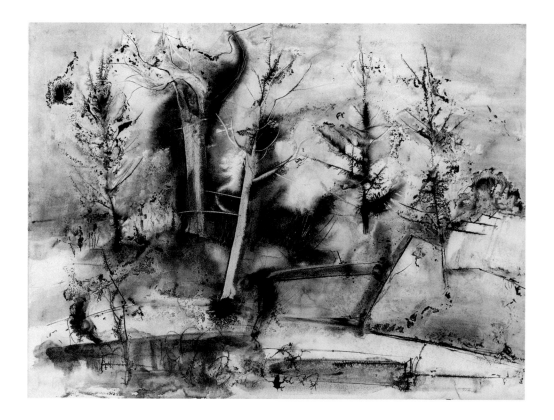

Mark Tobey
1890 USA–1976 Switzerland

Canticle
1954

casein on paper
17¾ x 11¹³⁄₁₆ (45 x 29.9)
provenance: Willard Gallery, New York, 1955

Throughout his life Tobey was deeply concerned with universal themes of man, nature, and God. In 1911, full of youthful ambition, he left Chicago for New York to become a fashion illustrator. His first exhibition, at M. Knoedler & Company in 1917, coincided with Tobey's first introduction to the Baha'i faith, whose interrelated concepts of unity, progressive revelation, and humanity would shape Tobey's art and life until his death. In 1922 Tobey began teaching at a progressive art school in Seattle and there studied calligraphy with a young Chinese artist, although thirteen years passed before it became integral to his art. From 1931 until 1938 Tobey taught in Devonshire, England, and in 1934, sponsored by a patron, he traveled to China and Japan. Improvising with calligraphy the following year, Tobey originated the distinctive "white writing" that marked his maturity as an artist. In the late 1950s experiments with sumi painting led Tobey to use broader strokes and patches of muted color. In 1960 Tobey settled in Basel, Switzerland, where he died in 1976.

George Tooker
born 1920

In the Summerhouse
1958

tempera on fiberboard
24 x 24 (61 x 61)
provenance: Edwin Hewitt Gallery, New York,
1958

Having completed his English degree at Harvard,
Tooker went to New York in 1943 to study at
the Art Students League, where he worked for
two years with Reginald Marsh. Like his friends
Jared French and Paul Cadmus, Tooker paints
in egg tempera and borrows compositional ar-
rangements from the Renaissance Italians, but
his thematic ties are with the existential ideas of
Jean-Paul Sartre and Samuel Beckett. Many of
Tooker's paintings contain a strong element of
implicit social comment, and he creates silent
theaters in which reality is transformed into
deadeningly repetitive drama. He uses precise,
geometric architectural structures as backdrops
for his protagonists, who often appear as
shrouded, shapeless masses contained within
boxes or cubicles. Human isolation, self-
alienation, and spiritually void rituals are
recurring themes in his work.

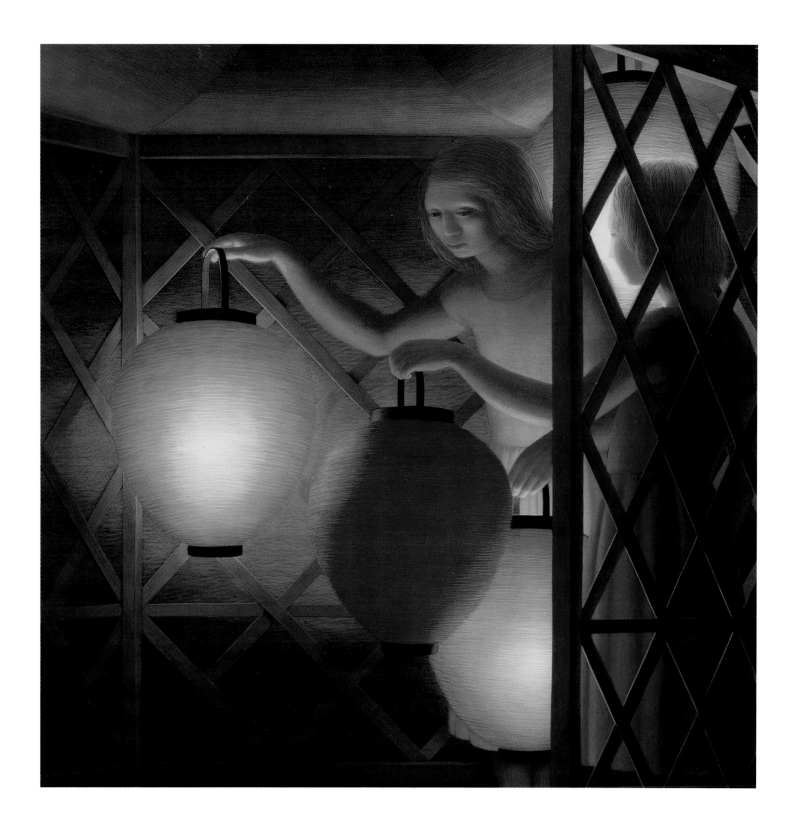

Harold Tovish
born 1921

Ceremonial Ax Head
1975

bronze on wood base
7⅛ x 13½ x 1½ (18.1 x 34.4 x 3.9)
provenance: Terry Dintenfass, Inc., New York,
1978

Harold Tovish is a sculptor who works in
bronze, wood, and synthetic media. He attended
WPA art classes in the late 1930s and studied
with Oronzio Maldarelli at Columbia University,
then went to Paris to work with Ossip Zadkine.
Tovish's early work reflects his experiments with
figurative naturalism, which he often used to
express themes of victimization. In 1949 his
ideas became explicit in a series of figures that
captured the horror he felt as a soldier exposed
to Nazi concentration camps at the end of
World War II. Throughout his work Tovish
seeks to unify form and content, placing heads
or fragments of heads within spaces that function
variously as refuges, prisons, or symbols of tech-
nological or societal entrapment. In the early
1950s, Tovish moved to Boston where he has
taught at the School of the Museum of Fine
Arts, at Massachusetts Institute of Technology,
and at Boston University. He spent 1965 as
artist-in-residence at the American Academy in
Rome.

Harold Tovish
In Memoriam
1984

hydrocal and gravel on wood base
approx. 45 x 48 x 48 (114.3 x 121.9 x 121.9)
provenance: Terry Dintenfass, Inc., New York,
1985

Robert Vickrey
born 1926

Fear
1954

egg tempera on paperboard
34¼ x 58¼ (87 x 148)
provenance: Midtown Galleries, New York, 1955

Vickrey attended Wesleyan University and completed a B.A. degree at Yale in 1947. The following winter he took classes with Kenneth Hayes Miller and Reginald Marsh at the Art Students League, then returned to Yale for a B.F.A. degree. The 1950s were successful years for Vickrey. In addition to painting, he made experimental films, and in 1957 began traveling around the world for *Time* magazine, doing sketches of movie stars and royalty. In his work Vickrey assumes the viewpoint of the realistic observer, but calls himself "anti-romantic," and says that to the careful viewer his paintings "always [convey] a sense of danger." He paints meticulously detailed images using egg tempera, but the contrived arrangements of figures and austere landscape elements reflect Vickrey's interest in transforming outmoded social and cultural symbols into forms that menace the individual. A memorial statue shrouded by drapery, for example, becomes "a corrupt beast of war."

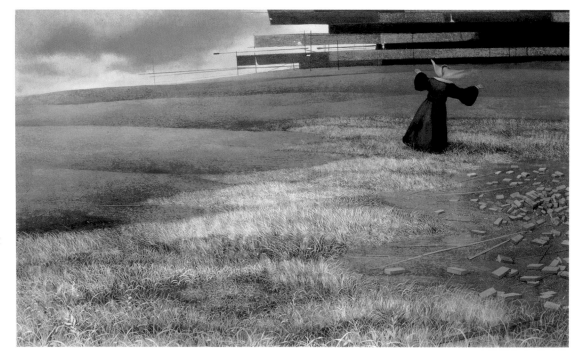

Alexander DeWitt Walsh
born 1947

Telepherique
1978

watercolor, gouache, and pencil on paper
24⁷⁄₁₆ x 24³⁄₈ (62 x 61.7)
provenance: the artist, 1982

Walsh attended the Art Students League, the
Rhode Island School of Design, and Hammer-
smith College of Art in London. Since 1963 he
has held a variety of art-related jobs, including
director of the gallery of the Artists Association
of Nantucket. In his paintings and drawings
Walsh explores the whimsy of childhood. He
sets children's toys into domestic interiors in
which carpet textures, moldings, and other ar-
chitectural details are precisely rendered. Placed
in otherwise empty spaces the tiny toys—boats,
soldiers, cable cars—reflect the simplicity and
distillation of elements typical of the Japanese
woodblocks that Walsh admires.

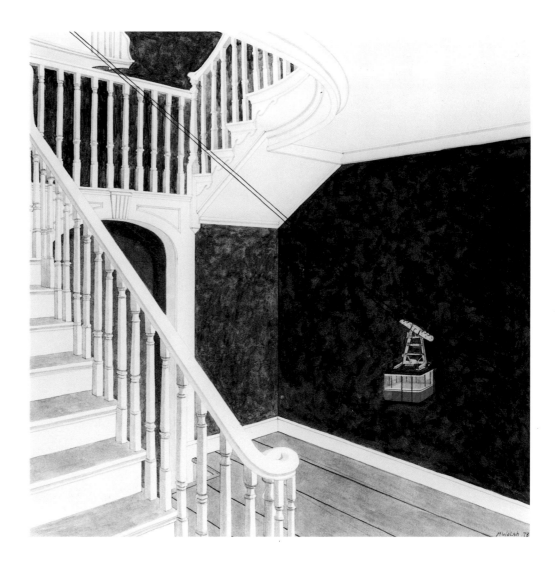

Max Weber
1881 Russia–1961 USA

Trio

1953

oil on canvas
25¼ x 30⅛ (64.1 x 76.5)
provenance: The Downtown Gallery, New York, 1956

At age ten Weber immigrated with his parents to Brooklyn. He studied at Pratt Institute and with Arthur Wesley Dow and subsequently taught in public schools in Virginia and Minnesota. In 1905 he left for Paris, where he met Matisse, Picasso, and other vanguard painters of the day and organized the art class taught by Matisse. On his return to New York in 1909, Weber emerged as a prominent figure in avant-garde circles. Weber's early paintings reflect his fascination with Futurist themes, Cubist space, and Fauve color, although around 1917 religious motifs assume increasing importance. During the second decade of the century Weber supported himself primarily by lecturing, and his 1916 *Essays on Art* were based on his teachings at the White School of Photography. Although Weber had a retrospective show at the Museum of Modern Art in 1930, it wasn't until the 1940s that his work received widespread public attention. His early experimental approach had by this time given way to an expressionistic style, and his canvases were frequent prizewinners in national exhibitions.

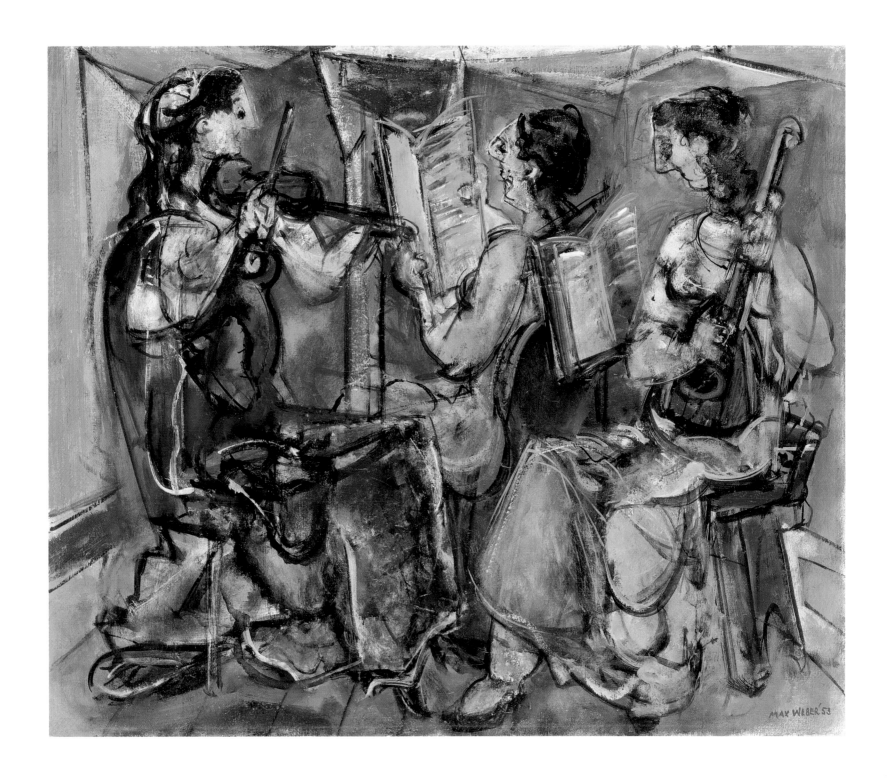

Charles Wells
born 1935

Sawney Bean IV
1967

acrylic on canvas
25¹⁄₁₆ x 27⅝ (63.8 x 70.3)
provenance: Far Gallery, New York, 1967

Wells, who initially intended to become a writer, began painting in an attempt to supplement his income. Around 1961, he discovered a book design by Leonard Baskin that wound up changing his life. Determined to study with the sculptor, he packed his paintings into his car, and headed for Northampton, Massachusetts, where Baskin was teaching. By the mid 1960s Wells had given up literary ambitions for his interest in the visual arts. He received a Prix de Rome and spent a year at the American Academy. In his sculpture and graphic work, Wells often chooses motifs related to humanity's struggle against unnatural restraints. He works with the theme of the individual as victim, and draws ideas from literature and contemporary social issues. Like his generalized figural compositions, his portraits have a haunting, masklike quality that probes psychological states rather than nuances of appearance.

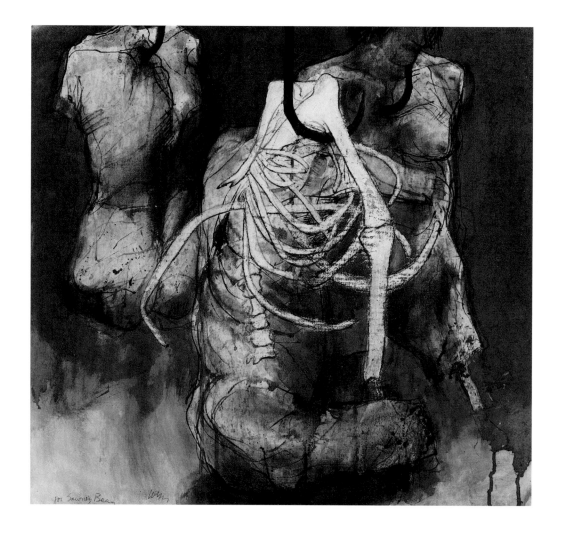

William Zorach
1889 Lithuania–1966 USA

Torso

1932

Labrador granite
33 x 18½ x 13½ (83.7 x 47 x 34.3)
provenance: Whitney Museum of American Art;
the artist; The Downtown Gallery, New York,
1957

Zorach took art classes at the Educational Alliance as a child and quit school at the end of the seventh grade to become an apprentice at a lithography firm. From 1905 to 1908 he studied drawing and painting at the Cleveland School of Art, then spent two years at the National Academy of Design in New York. In December 1910 he went to France intending to pursue a career as an academic painter, but Marguerite Thompson, his future wife, introduced him to avant-garde painting in the salons of Paris. Zorach's paintings in the second decade of this century demonstrate his fascination with Fauvism and Cubism, but ten years of avant-garde experimentation exhausted his enthusiasm and in 1922 he gave up painting for sculpture. Zorach's stone and wood carvings and his work in plaster and terra cotta are stylistically rooted in Egyptian, Greek, and, to some degree, in primitive art. His family members were frequent subjects, as were the family pets, and much of Zorach's art explores nuances of human emotion. Highly successful throughout much of his life, Zorach received many commissions, including *Spirit of Dance* for Radio City Music Hall.

Additional Works in the Sara Roby Foundation Collection

Robert Beauchamp
1923–1995

Untitled #1
1976
oil on canvas
47³/₄ x 95³/₄ (121.3 x 243.2)
provenance: Terry Dintenfass, Inc., New York, 1977

Robert Birmelin
born 1933

Concrete Viaduct
1960
conté crayon on paper
27¹⁵/₁₆ x 26¹/₈ (70.9 x 66.4)
provenance: Stable Gallery, New York, 1961

Wristwatch
1971
ink, ink wash, and pencil on paper
24 x 16¹/₂ (60.9 x 41.9)
provenance: Terry Dintenfass, Inc., New York, 1972

Isabel Bishop
1902–1988

Mending
1945
oil on fiberboard
25¹/₈ x 16⁷/₈ (63.7 x 42.8)
provenance: Midtown Galleries, New York, 1955

Students, Entrance to Union Square
1980
oil on plywood
30 x 28¹/₂ (76.2 x 72.4)
provenance: Midtown Galleries, New York, 1983

Hyman Bloom
born Lithuania 1913

Landscape
1958
sanguine conté crayon on paper mounted on canvas
20¹/₈ x 39³/₈ (51 x 100)
provenance: Swetzoff Gallery, Boston, 1958

Robert Broderson
born 1920

Father and Son by the Sea
n.d.
oil on canvas
60¹/₈ x 51 (152.8 x 129.5)
provenance: Mrs. Norma Frankel, Hillsdale, New York, 1981

Paul Cadmus
born 1904

Green Still Life
1954
casein, crayon, and pencil on paper
15³/₄ x 20¹/₁₆ (39.9 x 50.9)
provenance: Midtown Galleries, New York, 1955

Preliminary Sketch for Subway Symphony
1974
pencil, casein, crayon, and chalk on paper mounted on paperboard
21⁹/₁₆ x 40 (54.8 x 101.6)
provenance: Midtown Galleries, New York, 1977

Wynn Chamberlain
born 1928

The Barricade
1958
egg tempera on fiberboard
25 x 32¹/₈ (63.4 x 81.6)
provenance: the artist, 1958

Douglas Coffey
unknown

Feeder
n.d.
oil on canvas
47 x 47 (119.4 x 119.4)
provenance: Jo Sibley Gallery, Nantucket, 1985

Barry Dalgleish
born 1951

Interior with Trunk
n.d.
oil on canvas
65 x 48 (165.1 x 122)
provenance: Jo Sibley Gallery, Nantucket, 1984

Roy De Forest
born 1930

Drawing XVII
1974
oil crayon and colored pencil on paper
22⁷/₁₆ x 30¹/₈ (57 x 76.4)
provenance: Galerie Allen, Vancouver, 1974

Richard de Menocal
born 1919

Basket of Flowers
1978
oil on fiberboard
13⁷/₈ x 17⁷/₈ (35.2 x 45.4)
provenance: Main Street Gallery, Nantucket, 1982

The Kitchen Table
1982
oil on canvas
18 x 17 (45.8 x 43.3)
provenance: Main Street Gallery, Nantucket, 1982

Simon A. Dinnerstein
born 1943

Night Scene I
1982
conté crayon and colored pencil on paper
41³/₄ x 29³/₄ (106 x 75.5)
provenance: the artist, 1984

Arthur G. Dove
1880–1946

Oil Tanker II
1932
watercolor and conté crayon on paper
4⁷/₈ x 6⁷/₈ (12.3 x 17.4)
provenance: Gift of William C. Dove, 1979

Untitled
1942
pen and ink and crayon on paper mounted on paperboard
3¹⁵/₁₆ x 5⁵/₈ (10 x 14.3)
provenance: Gift of William C. Dove, 1979

Alan Evan Feltus
born 1943

Performer II
1980
oil on linen
40 x 30 (101.7 x 76.2)
provenance: Forum Gallery, New York, 1980

Elias Friedensohn
1924–1991

Expulsion from the Garden
1958
oil on canvas
52 x 78³/₄ (131.2 x 200)
provenance: Robert Isaacson Gallery, New York, 1959

Gregory Gillespie
born 1936

Landscape with Perspective
1975
oil, acrylic, and paper collage on wood
16¼ x 12½ (41.3 x 31.7)
provenance: Forum Gallery, New York, 1976

Joel Goldblatt
born 1923

Table Top with Bread (#4)
1970
oil on canvas
23⅞ x 23⅞ (60.7 x 60.7)
provenance: Peridot Gallery, New York, 1971

Rose Mary Gonnella-Butler
born 1957

Purple Interior with Window
1982
colored pencil and pencil on paper
25¹/₁₆ x 16⅝ (63.5 x 42.2)
provenance: Sibley Galleries, Nantucket, 1983

Lemon, Napkin and Cup
1983
colored pencil and pencil on paper
14⅛ x 18⅛ (35.8 x 46)
provenance: Sibley Galleries, Nantucket, 1983

Lemon Slices, Glass, and Cup
1983
colored pencil and pencil on paper
12⅛ x 18⅛ (30.7 x 45.9)
provenance: Sibley Galleries, Nantucket, 1983

Nancy Grossman
born 1940

5 Strap I
1968
pen and ink on paper
13⅞ x 17 (35.1 x 43.1)
provenance: Cordier & Ekstrom, Inc., New York, 1975

T.C. as a Young Man
1976
coated paper, masking tape, analine dyes, waterproof inks, and polymer glue on particle board
60½ x 36⅛ (153.7 x 91.7)
provenance: Cordier & Ekstrom, Inc., New York, 1976

Mare Imbrium
1981–82
paper, analine dyes, ink, and graphite on particle board
47⁷/₁₆ x 60⅛ (120.5 x 152.6)
provenance: Barbara Gladstone Gallery, New York, 1982

John André Gundelfinger
born France 1937

Dolly
n.d.
pencil on paper
8¹³/₁₆ x 10¾ (22.4 x 27.3)
provenance: John Bernard Myers Gallery, New York, 1973

Janet Compere Harwood
unknown

Evening Fairy Tale
ca. 1961
pen and ink on paper
20¼ x 26 (51.3 x 66.1)
provenance: the artist, 1961

Robert Hubbard
born 1916

Maritime #18
1967
marble
12 x 15 x 14½ (30.5 x 38.1 x 36.9)
provenance: the artist, 1970

Pedro A. Jimenez
unknown

Untitled
1972
colored ink on paperboard mounted on paperboard
15 x 19¹⁵/₁₆ (38.1 x 50.6)
provenance: the artist, 1974

James Joseph Kearns
born 1924

Model
1973
charcoal, crayon, and pastel on paper
72 x 48⅛ (183 x 122.2)
provenance: Sculpture Center, New York, 1973

William King
born 1925

Jongleur
1963
cast bronze on mirrored, plastic-covered base
8½ x 9⅛ x 6¾ (21.7 x 23.2 x 17.2)
provenance: Terry Dintenfass, Inc., New York, 1974

Connoisseur
1981
painted bronze on stone base
42½ x 11½ x 8 (108 x 29.2 x 20.3)
provenance: Terry Dintenfass, Inc., New York, 1981

The Good Old Days
1983
sheet aluminum
approximately 16 feet high
provenance: Terry Dintenfass, Inc., New York, 1985

Tux
1985
cast and painted bronze
28⅜ x 6 x 3⅞ (72.1 x 15.3 x 9.7)
provenance: Terry Dintenfass, Inc., New York, 1985

Patrick Klewicki
unknown

Studio Ceiling
ca. 1980
acrylic on canvas
29¾ x 60⅛ (75.7 x 152.8)
provenance: the artist, 1980

Jacob Lawrence
born 1917

Escape
1967
brush and ink, pen and ink, crayon, and pencil on paper
22¹/₁₆ x 29⁹/₁₆ (56 x 74.9)
provenance: Terry Dintenfass, Inc., New York, 1972

Keith McDaniel
1948–1986

Gloucester #2
1974
acrylic on linen
24⅛ x 36 (61.2 x 91.5)
provenance: Main Street Gallery, Nantucket, 1974

On the Wharf
1977
acrylic on canvas
32 x 48⅛ (81.3 x 122.3)
provenance: Main Street Gallery, Nantucket, 1977

Fort Warren
1981
acrylic on canvas
34 x 48⅛ (86.4 x 122.3)
provenance: Main Street Gallery, Nantucket, 1981

Loren MacIver
born 1909

White Garland
1980
oil on plywood
23⅞ x 29½ (60.6 x 74.9)
provenance: Pierre Matisse Gallery, New York, 1981

Reginald Marsh
1898 France–1954 USA

Bathing—Pick-a-Back
1952
pen and ink, ink wash, and pencil on paper
22⅝ x 30¹³/₁₆ (57.4 x 78.2)
provenance: Frank K. M. Rehn, Inc., New York, 1955

Richard Merkin
born 1938

Valentino by Mencken
1972
acrylic and crayon on paper
39⅜ x 28 (100 x 71)
provenance: Terry Dintenfass, Inc., New York, 1973

Cafe Megalomania
1979
charcoal and tempera on paper mounted on board
48¹/₁₆ x 60 (122 x 152.4)
provenance: Terry Dintenfass, Inc., New York, 1980

Gertrude and George
1979
pastel on paper
27¾ x 39⅜ (70.5 x 100)
provenance: Terry Dintenfass, Inc., New York, 1980

Roy Moyer
born 1921

Four Plums
1960
oil on canvas
26½ x 35½ (67.3 x 90.2)
provenance: The Contemporaries, New York,
1960

Autumn Still Life
1980
oil on canvas
30¼ x 30⅛ (76.9 x 76.5)
provenance: Carl Battaglia Galleries, New York,
1980

George Murphy
born England 1947

Hedge and Cypress
1977
oil on canvas
27½ x 27½ (69.8 x 69.8)
provenance: Sibley Galleries, Nantucket,
1982

At Back of the Atheneum I
1980
oil on canvas
29¾ x 29¾ (75.6 x 75.6)
provenance: Sibley Galleries, Nantucket,
1982

At Back of the Atheneum II
1980
oil on canvas
29⅞ x 30⅛ (75.9 x 76.5)
provenance: Sibley Galleries, Nantucket, 1982

Atheneum Clapboard
1980
oil on canvas
12 x 12 (30.5 x 30.5)
provenance: Sibley Galleries, Nantucket, 1982

At Back of the Atheneum II
1981
watercolor, ink, and graphite on paper
12⅛ x 10⅞ (30.8 x 27.7)
provenance: Sibley Galleries, Nantucket, 1982

Howard Newman
born 1943

Half Woman, Quarter Bird
1974–75
bronze
24⅛ x 13 x 20¼ (61.3 x 33 x 51.4)
provenance: Cordier & Ekstrom, Inc., New
York, 1975

Winter
1978
bronze
15 x 6½ x 8⅛ (38.1 x 16.5 x 20.7)
provenance: Cordier & Ekstrom, Inc., New
York, 1979

Untitled
1979
graphite and brown watercolor wash on paper
35¹/₁₆ x 23³/₁₆ (88.9 x 58.9)
provenance: Cordier & Ekstrom, Inc., New
York, 1979

Leigh Palmer
born 1943

Interior with Three Pears
1983
oil on linen
36 x 28⅛ (91.5 x 71.5)
provenance: Main Street Gallery, Nantucket,
1983

Theodore Roszak
1907 Poland–1981 USA

The Great Moth
1955
pen and ink, ink wash, and pencil on paper
68⁷/₁₆ x 28⁷/₁₆ (174 x 72.3)
provenance: Pierre Matisse Gallery, New York,
1956

Cornelis Ruhtenberg
born Latvia 1923

Sewing a Doll II
1972
acrylic on canvas
48 x 30 (122 x 76.2)
provenance: Forum Gallery, New York, 1974

Harold Tovish
born 1921

Particles II
1971
pen and ink and pencil on paper
19 x 25⅛ (48.3 x 63.7)
provenance: Terry Dintenfass, Inc., New York,
1972

Random Elements
1979
wood construction
12 x 8¾ x 9¼ (30.5 x 22.2 x 23.5)
provenance: Terry Dintenfass, Inc., New York,
1980

Gerald van de Wiele
born 1932

Pink Sky
1968
oil on canvas
30 x 35⅞ (76.2 x 91.2)
provenance: Peridot Gallery, New York, 1970

Alexander DeWitt Walsh
born 1947

Salvage
1982
oil on canvas
30 x 26 (76.1 x 66)
provenance: the artist, 1982

Bibliography

Will Barnet

Berger, Laurel. "Will Barnet." *Artnews* 93 (September 1994): 170.

Cole, Sylvan, Jr. *Will Barnet Etchings, Lithographs, Woodcuts, Serigraphs, 1932–1972, Catalogue Raisonné.* New York: American Artists Gallery, 1972.

Garfield, Joanna. "Will Barnet." *Art & Antiques* 9 (February 1992): 80.

Henry, Gerrit. "Will Barnet, Art Students League." *Artnews* 92 (February 1993): 109.

Wolfe, Townsend. *Will Barnet Drawings, 1930–1980.* Little Rock: Arkansas Arts Center, 1991.

Jack Beal

Beal, Jack. "Sight and Sense: Studying Pictorial Composition." *American Artist* 50 (February 1986): 54–61.

Saunders, Wade. "Making Art, Making Artists." *Art in America* 81 (January 1993): 87–88.

Shanes, Eric. *Jack Beal.* New York: Hudson Hills Press, 1993.

Robert Beauchamp

Campbell, Lawrence. "Robert Beauchamp at M-13 Gallery." *Art in America* 78 (April 1990): 271.

Kuchta, Ronald A. *Robert Beauchamp: American Expressionist.* Syracuse, N.Y.: Everson Museum of Art, 1984.

"Robert Beauchamp." [Obituary] *Art in America* 83 (May 1995): 134.

Waits, Donald. "Robert Beauchamp." *Arts Magazine* 62 (December 1987): 96.

Robert Birmelin

Berlind, Robert. "From the Corner of the Mind's Eye." *Art in America* 79 (March 1991): 113–17.

Grand, Stanley I., James M. Dennis, and Kathleen M. Daniels. *Between Heaven and Hell: Union Square in the 1930s.* Wilkes-Barre, Pa.: Sordoni Art Gallery, 1996.

Hurwitz, Rancie S. "Contemporary Masters: Robert Birmelin." *American Artist* 54 (April 1990): 24–29.

Lerman, Ora. "Contemporary Vanitas." *Arts Magazine* 62 (March 1988): 60–63.

Martin, Richard. "Robert Birmelin." *Arts Magazine* 60 (March 1986): 111.

Isabel Bishop

Barnett, Catherine. "A Woman of Substance: Remembering Isabel Bishop." *Art & Antiques* (December 1988): 65–71.

Ellett, Mary Sweeney. *Isabel Bishop: The Endless Search.* Ann Arbor, Mich.: University Microfilms International, 1987.

Isabel Bishop. Tucson: University of Arizona Museum of Art, 1974.

Newsom, Patricia Paull. "Isabel Bishop." *American Artist* 49 (September 1985): 42–45.

Yglesias, Helen. *Isabel Bishop.* New York: Rizzoli, 1989.

Hyman Bloom

Cotter, Holland. "Metaphor and Representation." *Art in America* 79 (February 1991): 138–41,161.

Cotter, Holland, and Dorothy Abbott Thompson. *Hyman Bloom, Paintings and Drawings.* Durham: University of New Hampshire, 1992.

Peter Blume

Trapp, Frank A. *Peter Blume: The Italian Drawings.* Amherst, Mass.: Mead Art Museum, 1985.

———. *Peter Blume.* New York: Rizzoli, 1987.

Robert Broderson

White, Patrick E. "Robert Broderson." *New Art Examiner* 14 (January 1987): 55.

Charles Burchfield

Davenport, Guy. *Charles Burchfield's Seasons.* San Francisco: Pomegranate Artbooks, 1994.

Maciejunes, Nannette. *The Paintings of Charles Burchfield.* New York: Harry N. Abrams, 1997.

Makowski, Colleen L. *Charles Burchfield: An Annotated Bibliography.* Lanham, Md.: Scarecrow Press, 1996.

Weekly, Nancy, ed. *Life Cycles: The Charles E. Burchfield Collection.* Buffalo, N.Y.: Burchfield–Penney Art Center, Buffalo State College, 1996.

Paul Cadmus

Brown, Hilton. "Paul Cadmus." *American Artist* 49 (January 1985): 24, 26.

Davenport, Guy. *The Drawings of Paul Cadmus.* New York: Rizzoli, 1989.

Kirstein, Lincoln. *Paul Cadmus* (rev. ed.). New York: Chameleon Books, 1992.

Sutherland, David. *Paul Cadmus: Enfant Terrible at 80.* [Video] Lowell, Mass.: Sutherland Productions, 1984.

Weinberg, Jonathan. "Cruising with Paul Cadmus." *Art in America* 80 (November 1992): 102–8.

Kenneth Campbell

Campbell, Kenneth. "Excerpts from 'Out of This the Sculptural Forms Come': The Posthumous Papers of Kenneth Campbell." *Leonardo* 21 (1988): 11–18.

Paul Caranicas

Haridopolos, Adam. "Paul Caranicas." *Arts Magazine* 61 (February 1987): 100.

Carmen Cicero

Kuspit, Donald B. "Carmen Cicero." *Art in America* 72 (December 1984): 165.

Mahoney, Robert. "Carmen Cicero." *Arts Magazine* 60 (February 1986): 128.

John Civitello

Civitello, John. Website: http://www.artplace.com/art/gallery/32/artplace/john_civitello/jcindex.htm

Stuart Davis

Davis, Earl. *Stuart Davis, Retrospective 1995.* Japan and New York: Koriyama City Museum of Art in collaboration with Salander-O'Reilly Gallery, 1995.

Davis, Stuart. "An Interview with Stuart Davis." *Archives of American Art Journal* 31, no. 2 (1991): 4–13.

Davis, Stuart, Estate of. *Stuart Davis Sketchbooks.* New York: Grace Borgenicht Gallery and the Arts Publisher, 1986.

Hills, Patricia. *Stuart Davis.* New York: Harry N. Abrams, 1996.

Sims, Lowery Stokes. *Stuart Davis, American Painter.* New York: Metropolitan Museum of Art, 1992.

Weber, Bruce. *Stuart Davis' New York.* West Palm Beach, Fla.: Norton Gallery of Art, 1985.

Wilkin, Karen, and Lewis Kachur. *The Drawings of Stuart Davis.* New York: American Federation of Arts in association with Harry N. Abrams, 1992.

Wilson, William. *Stuart Davis's Abstract Argot*. San Francisco: Pomegranate Artbooks, 1993.

José de Creeft

Hanson, Bob. *José de Creeft; A Film*. Bloomington: Indiana University, 1993.

"José de Creeft: Sculpture and Drawing, 1917–1940." New York: Childs Gallery, 1990.

"The Watercolors of José de Creeft." New York: Snyder Fine Art, 1992.

Roy De Forest

Chadwick, Whitney. "Narrative Imagism and the Figurative Tradition in Northern California Painting." *Art Journal* 45 (Winter 1985): 309–14.

De Forest, Roy. *A Journey to the Far Canine Range and the Unexplored Territory Beyond Terrier Pass*. San Francisco: Bedford Arts, 1988.

Nixon, Bruce. "Kaleidoscopic Road Maps." *Artweek* 21 (July 5, 1990): 13–14.

Schick Art Gallery. *Out of Abstract Expressionism*. Skidmore College, 1991.

Tromble, Meredith. "A Conversation with Roy De Forest." *Artweek* 24 (June 3, 1993): 14.

Simon Dinnerstein

Dinnerstein, Simon. "Looking at One's Own Artwork." *American Artist* 50 (April 1986): 68–71.

Messer, Thomas M., and Albert Boime. *The Art of Simon Dinnerstein*. Fayetteville: University of Arkansas Press, 1990.

Arthur Dove

Cassidy, Donna. "Arthur Dove's Music Paintings of the Jazz Age." *American Art Journal* 20:1 (1988): 4–23.

Cohn, Sherrye. *Arthur Dove: Nature as Symbol*. Ann Arbor, Mich.: UMI Research Press, 1985.

Eldredge, Charles C. *Reflections on Nature: Small Paintings by Arthur Dove, 1942–1943*. New York: American Federation of Arts, 1997.

Messinger, L. "Arthur Dove: Fishboat." *Metropolitan Museum of Art Bulletin* 53 (Fall 1995): 62.

Morgan, A. L. "New Discoveries in American Art." *American Art Journal* 20:4 (1988): 100–1.

Roth, E. "Dove Painting and Studies: National Museum of American Art." *Museum News* 69 (May–June 1990): 48–49.

Stieglitz, Alfred. *Dear Stieglitz, Dear Dove*. Newark: University of Delaware Press; London; Cranbury, N. J.: Associated University Presses, 1988.

Jimmy Ernst

Dreishpoon, Douglas, and Martica Sawin. *Jimmy Ernst, 1920–1984: Retrospective*. Naples, Fla., and Youngstown, Ohio: Harmon Meeks Gallery in association with Butler Institute of American Art, 1994.

Jimmy Ernst; Trials of Silence, Works 1942–1983. Tampa, Fla.: Tampa Museum of Art, 1994.

Philip Evergood

Taylor, Kendall. *Philip Evergood: Never Separate from the Heart*. Lewisburg, Pa.: Bucknell University, 1987.

Weisberg, Ruth. "Reassessing a Social Realist." *Artweek* 18 (March 14, 1987): 1.

Alan Evan Feltus

Feltus, Alan. *Alan Feltus: New Paintings*. New York: Forum Gallery, 1996.

——. "Living and Working in Italy." *American Artist* (August 1992): 54–57.

Grimes, N. "Alan Feltus at Forum." *Art in America* 84 (October 1996): 121.

Sondra Freckelton

Bolt, Thomas. "Reckless, Brave, or Both: New Paintings by Sondra Freckelton." *Arts Magazine* 60 (January 1986): 52–53.

"A Survey of Contemporary Art of the Figure." *American Artist* 49 (February 1985): 62–71.

Elias Friedensohn

Birmelin, Robert. *Elias Friedensohn: Airports and Escapes: Paintings and Drawings, 1987–1991*. Flushing: Queens College, City University of New York, 1993.

Elias Friedensohn. Paramus, N. J.: Bergen Museum of Art and Science, 1993.

Friedensohn, Elias. "The Weather on Patmos Is Just Fine." *The New Criterion* 5 (January 1987): 33–44.

Suzi Gablik

Bartlett, Mark. "A Conversation with Suzi Gablik and Lucy Lippard." *Artweek* 22 (December 19, 1991): 11–12.

Bolton, R. "Beauty Redefined: From Ideal Form to Experiential Meaning." *New Art Examiner* 21 (November 1993): 29–30.

Gablik, Suzi. "Dancing with Baudrillard." Tape recording of speech, Visiting Artists Program, School of the Art Institute of Chicago, October 21, 1987.

Gregory Gillespie

Brookman, Philip. "Defining the Boundaries of Realism." *Artweek* 15 (September 29, 1984): 5.

Gillespie, Gregory. *Self-Portraits, 1969–1991: A Comprehensive Survey*. New York: Forum Gallery, 1992.

Henry, Gerrit. "Gregory Gillespie's Manic Masterpieces." *Artnews* 85 (December 1986): 116–20.

Worth, A. "Gregory Gillespie." *Artnews* 95 (September 1996): 131.

Sidney Goodman

Csaszar, T. "Sidney Goodman." *New Art Examiner* 23 (April 1996): 46.

Goodman, J. "Sidney Goodman." *Artnews* 94 (September 1995): 143.

Johnson, K. "Portraits and Portents." *Art in America* 84 (September 1996): 94–101

Ravenal, John B. *Sidney Goodman: Paintings and Drawings, 1959–95*. Philadelphia: Philadelphia Museum of Art, 1996.

Stein, Judith "Sidney Goodman." *Artnews* 95 (May 1996): 85–86.

Morris Graves

McDonald, Robert. *Morris Graves: Works of Fifty Years*. Santa Clara, Calif.: De Saisset Museum, 1990.

Scarbrough, James. "A Restless Man." *Artweek* 23 (January 23, 1992): 18.

Wolff, Theodore F. *Morris Graves: Flower Paintings*. Seattle: University of Washington Press, 1994.

Woodard, Joseph. "Insights from a Nocturnal World." *Artweek* 20 (January 14, 1989): 1–2.

Nancy Grossman

Raven, Arlene. *Nancy Grossman*. Brookville, N.Y.: Hillwood Art Museum, Long Island University, 1991.

Stevens, M. "Nancy Grossman." *New Art Examiner* 19 (June/Summer 1992): 53–54.

Vine, R. "Nancy Grossman." *Art in America* 82 (November 1994): 132.

George Grosz

Flavell, Mary Kay. *George Grosz, a Biography*. New Haven: Yale University Press, 1988.

Grosz, George. *George Grosz: Berlin–New York*. Berlin: Ars Nicolai, 1994.

——. *The Sketchbooks of George Grosz*. Cambridge, Mass.: Busch-Reisinger Museum, Harvard University Art Museums, 1993.

Kane, Martin. *Weimar Germany and the Limits of Political Art: A Study of the Work of George Grosz and Ernst Toller*. Tayport, Scotland: Hutton Press, 1987.

Lewis, Beth Irwin. *George Grosz: Art and Politics in the Weimar Republic*. Princeton, N.J.: Princeton University Press, 1991.

McCloskey, Barbara. *George Grosz and the Communist Party: Art and Radicalism in Crisis, 1918 to 1936*. Princeton, N. J.: Princeton University Press, 1997.

John Gundelfinger

Henry, Gerrit. [Exhibition review]. *Art in America* 75 (December 1987): 159–60.

John Heliker

John Heliker: A Celebration of Fifty Years. New York: Kraushaar Galleries, Inc., 1995.

Perl, Jed. "Irreconcilable Differences." *The New Criterion* 10 (June 1992): 51–56.

——. "Versions of Pastoral." *The New Criterion* 4 (June 1986): 48–55.

Edward Hopper

Levin, Gail. *Edward Hopper: A Catalogue Raisonné*. New York: Whitney Museum of American Art and W. W. Norton, 1995.

——. *Edward Hopper: An Intimate Biography*. New York: Knopf, 1995.

Marling, Karal Ann. *Edward Hopper*. New York: Rizzoli, 1992.

Wolf Kahn

Kahn, Wolf. "Autocratic and Democratic Still Lifes." *American Artist* 50 (February 1986): 62–69.

——. "Connecting Incongruities." *Art in America* 80 (November 1992): 116–21.

Spring, Justin. *Wolf Kahn*. New York: Harry N. Abrams, 1996.

Ben Kamihira

Davidson, Abraham A. *Ben Kamihira: Paintings*. New York: Gallery Urban, 1987.

Herbert Katzman

Herbert Katzman Drawings. Youngstown, Ohio: Butler Institute of American Art, 1993.

Rubenstein, Raphael. "Herbert Katzman at Terry Dintenfass." *Art in America* 82 (May 1994): 116.

Leon Kelly

Campbell, Lawrence. "Leon Kelly at A.M. Adler Fine Arts." *Art in America* 75 (January 1987): 137.

William Kienbusch

Belanger, Pamela J. et al. *William Kienbusch: A Retrospective Exhibition, 1946–1979*. Rockland, Maine: Farnsworth Art Museum, 1996.

Pardee, Hearne. "Landscape and the Language of Abstraction." *Arts Magazine* 60 (September 1985): 134–35.

William King

Berger, Laurel. "William King." *Artnews* 94 (January 1995): 159.

Henry, Gerrit. *William King: Sculpture King Scores*. New York: Terry Dintenfass, Inc., 1986.

Upshaw, R. "William King at Terry Dintenfass." *Art in America* 83 (January 1995): 100–1.

Karl Knaths

Thomas, Stevens. *Provincetown Printing Blocks*. Provincetown, Mass.: Provincetown Art Association and Museum, 1988.

Yasuo Kuniyoshi

Davis, Richard Allen. *Yasuo Kuniyoshi: The Complete Graphic Work*. San Francisco: Alan Wofsy Fine Arts, 1991.

Myers, Jane. *The Shores of a Dream: Yasuo Kuniyoshi's Early Work in America*. Fort Worth, Tex.: Amon Carter Museum, 1996.

Riehlman, Franklin, Tom Wolf, and Bruce Weber. *Yasuo Kuniyoshi: Artist as Photographer*. Annandale-on-Hudson, N. Y.: Edith C. Blum Art Institute, Milton and Sally Avery Arts Center, Bard College Center with the Norton Gallery and School of Art, 1983.

Wolf, Tom. *Yasuo Kuniyoshi's Women*. San Francisco: Pomegranate Artbooks, 1993.

Bruce Kurland

Little, Carl. "Bruce Kurland." *Art in America* 79 (June 1991): 148–49.

Gaston Lachaise

Hunter, Sam. *Gaston Lachaise*. New York: Cross River Press, 1993.

Morgan, A. B. "Gaston Lachaise." *Sculpture* (May/June 1996): 74.

Wilkin, Karen. "Gaston Lachaise and His Muse." *Sculpture Review* 41 (1992): 8–17.

———. "Woman and Gaston Lachaise." *The New Criterion* 10 (March 1992): 56–61.

Edward Laning

Wooden, Howard. *Edward Laning: Paintings and Drawings*. New York: Kennedy Galleries, 1992.

Jacob Lawrence

Collins, Amy Fine. "Jacob Lawrence: Art Builder." *Art in America* 76 (February 1988): 130–35.

Howard, Nancy Shroy. *Jacob Lawrence: American Scenes, American Struggles*. Worcester, Mass.: Davis Publications, 1996.

Powell, Richard J. *Jacob Lawrence*. New York: Rizzoli, 1992.

Turner, Elizabeth Hutton, ed. *Jacob Lawrence: The Migration Series*. Washington, D.C.: Rappahannock Press in association with the Phillips Collection, 1993.

David Levine

Bass, Ruth. "David Levine." *Artnews* 86 (September 1987): 140.

Moynihan, Daniel Patrick. *Artists, Authors, and Others: Drawings by David Levine*. Washington, D.C.: Smithsonian Institution Press, 1976.

Rundgren, Todd. *Music for the Eye: Digital Apparitions from Todd Rundgren and David Levine*. Berkeley, Calif.: Celestial Arts, 1996.

The Watercolors of David Levine. Washington, D.C.: Phillips Collection, 1980.

Jack Levine

Cotter, Holland. "The Vanities Afire: Jack Levine." *Art in America* 79 (May 1991): 142–45.

Frankel, Stephen, and Jack Levine. *Jack Levine*. New York: Rizzoli, 1989.

Henry, Gerrit. "Jack Levine." *Artnews* 92 (Summer 1993): 169.

Prescott, Kenneth W., and Emma-Stina Prescott. *The Complete Graphic Work of Jack Levine*. New York: Dover Publications, 1984.

Sutherland, David. *Jack Levine: Feast of Pure Reason* (video). Lowell, Mass.: David Sutherland Productions, distribution by Home Visions, 1986.

Yellin, Deborah. "Jack Levine." *Artnews* 90 (January 1991): 149.

David Ligare

Pincus, Robert L. "David Ligare." *Art in America* 75 (April 1987): 228–29.

Welles, Eleanore. "History Painting Revisited." *Artweek* 17 (December 6, 1986): 5.

Louis Lozowick

Marquardt, Virginia H. *Survivor from a Dead Age: The Memoirs of Louis Lozowick*. Washington, D.C.: Smithsonian Institution Press, 1997.

Roman, Gail Harrison, and Virginia H. Marquardt, eds. *The Avant-garde Frontier: Russia Meets the West, 1910–1930*. Gainesville: University of Florida Press, 1992.

Stretch, Bonnie Barrett. "Louis Lozowick." *Artnews* 92 (March 1993): 114.

Bruno Lucchesi

Finn, David, and Dena Merriam. *Bruno Lucchesi: Sculptor of the Human Spirit*. New York: Hudson Hills Press, 1989.

Ann McCoy

Gould, Claudia. "Mythologies of the Feminine: A Conversation with Ann McCoy." *Arts Magazine* 63 (February 1989): 66–71.

McCoy, Ann. *New Roman Works: Rome 1989–1990*. New York: Arnold H. Herstan, Inc., 1990.

Selz, Peter. "Alternative Aesthetics: Quests for Spiritual Quintessence." *Arts Magazine* 62 (October 1987): 46–49.

Van Proyen, Mark. "The Hieroglyphics of Ambivalence." *Artweek* 17 (October 4, 1986): 1, 4.

Loren MacIver

Edelman, Robert G. "MacIver's Luminous Visions." *Art in America* 82 (February 1994): 80–83.

Garbrecht, Sandra. *Loren MacIver: The Painter and the Passing Stain of Circumstance*. Washington, D.C.: Georgetown University Press, 1987.

Santlofen, Jonathan. "Lions in Winter." *Artnews* 92 (March 1993): 86–91.

Marisol

De Lamater, Peg. "Personal Selection: Marisol's Public and Private de Gaulle." *American Art* 10 (Spring 1996): 91–93.

Gardner, Paul. "Who Is Marisol?" *Artnews* 88 (May 1989): 146–51.

Grove, Nancy. *Magical Mixtures: Marisol Portrait Sculpture*. Washington, D.C.: Smithsonian Institution Press for the National Portrait Gallery, 1991.

Schwendenwien, J. "Marisol." *Sculpture* 15 (January 1996): 77.

Reginald Marsh

Bruhn, Thomas P. *Reginald Marsh: Coney Island*. Fort Wayne, Ind.: Fort Wayne Museum, 1991.

Cohen, Marilyn Ann. *Reginald Marsh: An Interpretation of His Art*. Ann Arbor, Mich.: University Microfilms International, 1988.

Stretch, Bonnie Barrett. "Reginald Marsh." *Artnews* 95 (December 1996): 122–23.

Richard Mayhew

Campbell, Mary Schmidt. *Richard Mayhew, An American Abstractionist*. New York: Studio Museum in Harlem, 1978.

Collins, Amy Fine. "Richard Mayhew." *Art in America* 76 (February 1988): 141.

Welsh, Clarissa J. "Alchemists." *Artweek* 24 (September 23, 1993): 18–19.

Michael Mazur

Conklin, Jo-Ann. *The Inferno: Monotypes by Michael Mazur*. Iowa City: University of Iowa Museum of Art, 1994.

Sandback, Amy Baker. "Not Fully Repeatable Information: Michael Mazur and Monotypes, an Interview." *Print Collector's Newsletter* 21 (November/December 1990): 180–81.

Stapen, N. "Michael Mazur: Interpreting Hell." *Artnews* 94 (November 1995): 103.

Richard Merkin

Gallati, Barbara D. *Broken Blossoms and Other Pictures: Recent Paintings by Richard Merkin*. Syracuse, N.Y.: Joe and Emily Lowe Art Gallery, Syracuse University, 1985.

Kenneth Hayes Miller

Brown, Hilton. "Fame and Fortune in the Art World." *American Artist* 51 (March 1987): 46–51, 80–83.

Louise Nevelson

Lipman, Jean. *Nevelson's World*. New York: Hudson Hills Press in association with the Whitney Museum of American Art, 1983.

Lisle, Laurie. *Louise Nevelson: A Passionate Life*. New York: Summit Books, 1990.

Schwartz, Connie. *Nevelson and O'Keeffe: Independents of the 20th Century*. Roslyn Harbor, N.Y.: Nassau County Museum of Fine Art, 1983.

Leigh Palmer

Cohen, Ronny. "Leigh Palmer." *Artforum* 27 (December 1988): 123.

Hoffman, R. "A Painterly Approach to Encaustic." *American Artist* 60 (September 1996): 34–39.

William C. Palmer

"Discovery: Up Against the Wall: A Hospital Locksmith Unlocks the Mystery of the Palmer Murals." *Art & Antiques* (December 1988): 41.

Herzfeld, John. "Medical Recovery." *Artnews* 88 (January 1989): 14.

Sutherland, David, and Nancy Sutherland. *William C. Palmer* [video]. Utica, N.Y.: Munson-Williams-Proctor Institute, 1989.

Robert Andrew Parker

Edelman, R. G. "Robert Andrew Parker at Terry Dintenfass." *Art in America* 83 (December 1995): 96.

Guy Pène du Bois

Grand, Stanley I. *Guy Pène du Bois: The Twenties at Home and Abroad*. Wilkes-Barre, Pa.: Sordoni Art Gallery, 1995.

Joseph Raffael

Henry, Gerrit. "Joseph Raffael." *Art in America* 79 (May 1991): 174–75.

Kuspit, Donald B. "Joseph Raffael." *Artforum* 34 (March 1996): 101.

McManus, Irene. "Joseph Raffael's 'Lannis Series, Part One.'" *Arts Magazine* 62 (March 1988): 26–28.

Paul Resika

DiPiero, W. S., and Karen Wilkin. *Paul Resika: Paintings*. New York: Salander-O'Reilly Galleries, 1993.

Tatransky, V. "The Importance of Subject Matter in the Art of Paul Resika." *Arts Magazine* 59 (June 1985): 136–37.

Theodore Roszak

Dreishpoon, Douglas. *Between Transcendence and Brutality: American Sculptural Drawings from the 1940s and 1950s*. Tampa, Fla.: Tampa Museum of Art, 1994.

———. *Theodore J. Roszak (1907–1981)*. Ann Arbor, Mich.: University Microfilms International, 1993.

Marter, Joan M. *Theodore Roszak: The Drawings*. New York: Drawing Society, 1992.

Wooden, Howard E. *Theodore Roszak, The Early Work*. Wichita, Kans.: Wichita Art Museum, 1986.

Ben Shahn

Edwards, Susan H. *Ben Shahn: A New Deal Photographer in the Old South*. Ann Arbor, Mich.: University Microfilms International, 1996.

Pohl, Frances K. *Ben Shahn*. San Francisco: Pomegranate Artbooks, 1993.

———. *Ben Shahn: New Deal Artist in a Cold War Climate, 1947–1954*. Austin: University of Texas Press, 1989.

Prescott, Kenneth Wade. *Ben Shahn Retrospective Exhibition, 1991*. Tokyo: Fukushima Prefectural Museum of Art, 1991.

Raphael Soyer

Bass, Ruth. "Raphael Soyer." *Artnews* 94 (April 1995): 144–45.

Lerner, Abram. *Soyer Since 1960*. Washington, D.C.: Smithsonian Institution Press for Hirshhorn Museum and Sculpture Garden, 1982.

Soyer, Raphael. "Artists in Focus: Photographs of and Statements by Contemporary Artists." *American Artist* 50 (September 1986): 24.

Soyer, Raphael. *Life Drawings and Portraits*. New York: Dover Publications, 1986.

Saul Steinberg

Hollander, John. *Dal Vero: Portraits by Saul Steinberg*. New York: Library Fellows of the Whitney Museum of American Art, 1983.

Kuspit, Donald. "Saul Steinberg." *Artforum* 31 (March 1993): 91.

Steinberg, Saul. *The Discovery of America*. New York: Knopf, 1992.

William Thon

Creative Lives: The Art of Edward Betts, Dahlov Ipcar, Cabot Lyford and William Thon. Ogunquit, Maine: Ogunquit Museum of American Art, 1996.

Mark Tobey

Frankenstein, Alfred. "Mark Tobey." *Artforum* 26 (February 1988): 24–26.

Fryberger, Betsy G., Paul Cummings, and Judith S. Kays. *Mark Tobey: Works on Paper from Northern California and Seattle Collections*. Stanford, Calif.: Stanford University Museum of Art, 1990.

Kelly, Edward Rulief. *Mark Tobey and the Baha'i Faith: New Perspectives on the Artist and His Paintings*. Ann Arbor, Mich.: University Microfilms International, 1987.

Reiner, Michele. *Mark Tobey: Between Worlds: Works, 1935–1975*. Essen, Germany: Museum Folkwang Essen, 1989.

Tobey, Mark. *Feininger and Tobey: Years of Friendship: The Complete Correspondence*. New York: Achim Moeller Fine Art, 1991.

George Tooker

Baker, Susan Jane. *George Tooker and the Modern Tradition*. Ann Arbor, Mich.: University Microfilms International, 1996.

Heffernan, Ildiko. *George Tooker: Working Drawings*. Burlington, Vt.: Robert Hull Fleming Museum, University of Vermont, 1987.

Kane, Marie Louise. "George Tooker's Magic Numbers." *Artnews* 92 (January 1993): 29.

Wechsler, Jeffrey. "Magic Realism: Defining the Indefinite." *Art Journal* 45 (Winter 1985): 293–96.

Harold Tovish

Harold Tovish: A Retrospective Exhibition, 1948–1988. Andover, Mass.: Addison Gallery of American Art, Phillips Academy, 1988.

Koslow, Francine A. "Harold Tovish." *Artforum* 27 (March 1989): 137.

Parcellin, P. "Harold Tovish: Resonant Images." *Art New England* 17 (December 1995–January 1996): 66.

Robert Vickrey

Vickrey, Robert. "Robert Vickrey Reveals His Whitewashing Technique." *American Artist* 57 (June 1993): 40–47.

Henry, Gerrit. "Robert Vickrey." *Artnews* 90 (January 1991): 151–52.

Max Weber

Kenner, Hugh. "Brooklyn's Braque: How Max Weber Brought Cubism to America." *Art & Antiques* (March 1992): 120.

Kramer, Hilton. "A Misalliance with Modernism." *Art & Antiques* (September 1992): 78–79.

North, Percy. *Max Weber: The Cubist Decade, 1910–1920*. Atlanta: High Museum of Art, 1991.

William Zorach

Hoffman, Marilyn Friedman. *Marguerite and William Zorach: The Cubist Years, 1915–1918*. Manchester, N.H.: Currier Gallery of Art, 1987.

Masters, Greg. "William Zorach." *Arts Magazine* 60 (March 1986): 108.